ordered from
western Horseman
8/08

BRANDS
OF THE WEST

S

Stoecklein Publishing

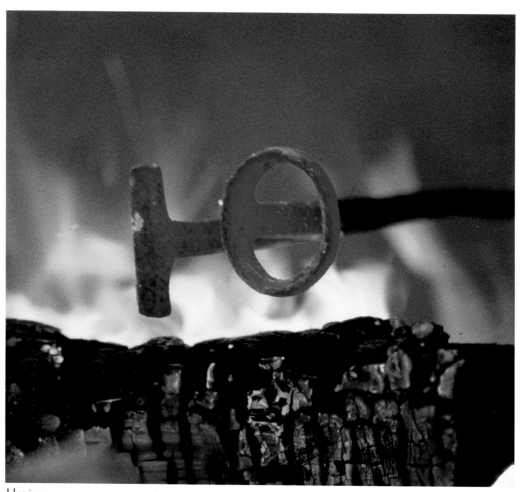

Hot iron
Bar Horseshoe Ranch
Mackay, Idaho

BRANDS
OF THE WEST

Photography – David R. Stoecklein
Art Direction & Design – Adrienne Leugers
Creative Director – David R. Stoecklein
Editor – Carrie Lightner

Cover: Hubing Ranch, Broadus, Montana
Back Cover: Dragging Y Ranch, Dillon, Montana
Following Page: Waiting for the branding to begin, Haythorn Ranch, Arthur, Nebraska

Stoecklein Publishing
Tenth Street Center, Suite A1
Post Office Box 856, Ketchum, Idaho 83340
(208)726-5191 phone • (208)726-9752 fax • (800)727-5191
www.thestoeckleincollection.com
Printed in China

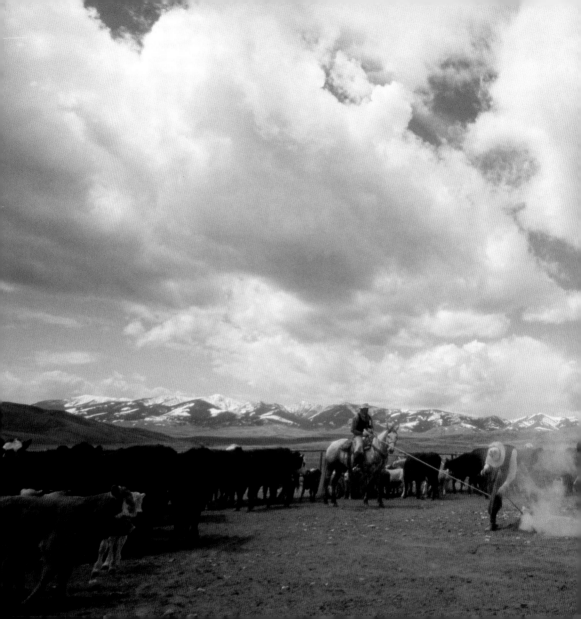

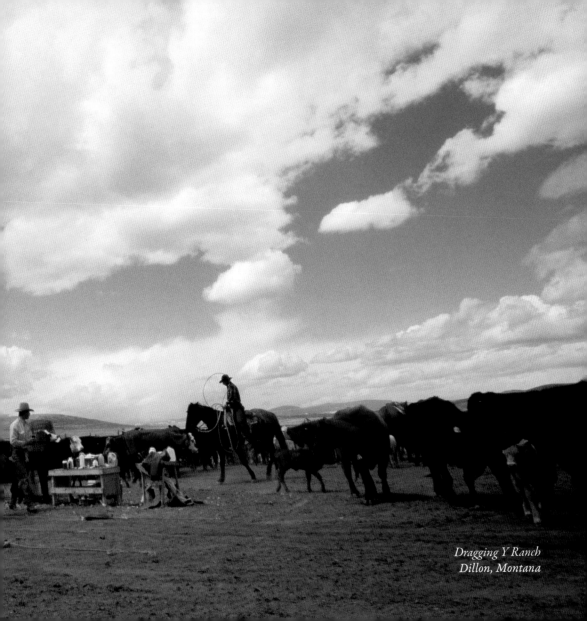

Dragging Y Ranch
Dillon, Montana

Foreword

by David R. Stoecklein

I would bet that I have been told at least 50 times by a rancher or a cowboy to come back at branding time to get some great photographs and see the cowboys at their best—roping calves and dragging them to the fire—the real action shots. But I was never sure that anyone would buy a book titled *Branding Time in California,* for example. So, I continued taking photographs of ranchers and cowboys working cattle, moving cattle, doctoring cattle, breaking horses, riding horses, herding horses, and so on. Of course, I also photographed a few brandings. Branding is done everywhere and in every state. The branding shoots were fun and easy to do—it was simple to capture cowboys and cowgirls roping under the big western sky.

I photographed my first branding 20 years ago. It was the day my son, Taylor, was born. My oldest son, Drew, went with me to Harold Drussel's ranch in the Bellevue Triangle, south of Sun Valley, Idaho, where I live. My good friend Ray Seal wanted me to come down and see the action. Frankly, I did not know what to expect and the photographs did not turn out so well. The most important thing that came out of that day was finding out that Drew, who was three years old, was allergic to horses.

Next, I went to a branding at Larry Christensen's ranch in McCammon, Idaho with my old buddy, Monte Funkhouser. That is when I really got into the photographs and into the branding; they

David Stoecklein's cattle brand
F8 is the "f-stop" he loves using on his Canon cameras

even let me rope. I remember I wanted to try out my new rawhide reata. And try I did. I threw that poor rope until my arms and the rope were completely worn out. I may have caught one or two calves at the most, and all the cowboys were laughing their guts out. Now I go to lots of brandings, not only to take photographs but also to rope and drag calves. I would go to a branding every day if I could. Personally, I love to be where they head and heal the calves.

I have seen almost all the different styles of branding in the country. It is done differently in Texas than in California or Idaho and differently in Montana than in Arizona. They all get the job done and they all have fun doing it. No way is better than the other. After shooting so many branding images, the old challenge always comes back: how do I make the photographs different from before? After all, it is my job to show the reader different ways of seeing the same thing. So I started lying down among the calves and letting the ropers cast their ropes right at me. I followed the calves, running with them as they were dragged to the fire. I climbed on top of horse trailers and shot down across the prairie, through the fence, through the ropes. I slowed down the shutter speed on my camera to show blurred action. I have tried it all and I am still trying to give my readers something new to look at, a new way to see things we all see every day.

Like with all of my books, I want to educate you, I want to entertain you, and of course, most importantly, I want to preserve the West. So please enjoy this little volume; I hope you learn something and have fun reading it.

Keep the spirit of the West alive,

David R. Stoecklein

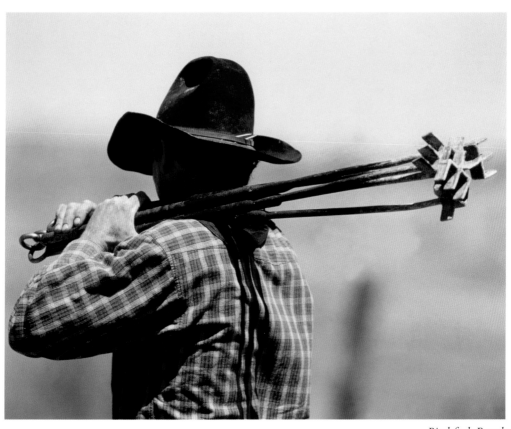

Pitchfork Ranch
Guthrie, Texas

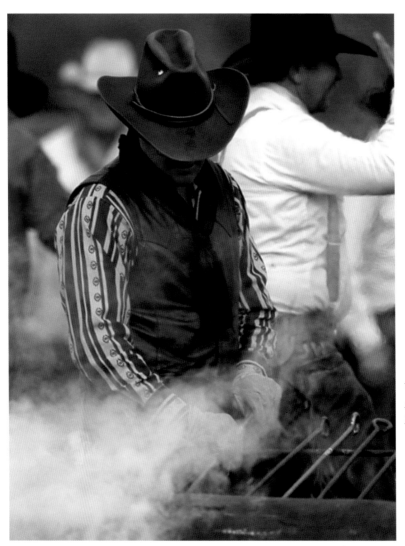

Waiting for a hot iron
Hubing Ranch
Broadus, Montana

Western bar
Elko, Nevada

History of Brands

(reprinted from *Cowboy Gear*)

Brands were the trademarks of the range, identifying an animal's owner. In each county, cattle and horse ranchers registered their unique brand design in a "brand book," and described the mark's placement on their animals. Cattle were also marked by distinguishing cuts, usually on the ears, dewlaps, or other folds of skin.

> Brands were the trademarks of the range, identifying an animal's owner.

A brand was burnt onto the hide of an animal with a fire-heated iron. A cowboy learned how to brand from experience. There was a trick to knowing the correct temperature for branding. An iron too hot would burn the animal, blot the desired design, and possibly create a dangerous wound. Too cool an iron would render a brand that would rub off down the trail.

Generally, branding irons were made in two styles—the stamp iron, which bore the owner's

One of the oldest brands in the U.S.
Tejon Ranch, Lebec, California

design and produced a "set brand" upon application, and the running or "slick" iron, which was used freehand, like a pencil, to draw the desired mark. The running iron's flexibility made it a favorite with cattle thieves, who also made do with broken horseshoes, pieces of bits, and occasionally, wire or a cookpot hook. The typical iron was two to three feet long, and made of ¾-inch iron. Some irons had wooden handles that reduced the heat for operator's hands. Well into the 20th century, all branding irons were made of malleable iron, hammered into shape by hand. A shorter handle made an iron harder to manage, yet easier to pack in the field.

> The typical iron was two to three feet long, and made of ¾-inch iron.

Ranchers usually designed brands that described some aspect of their names, or a landmark or event that was important to them. Another consideration when choosing a brand was the mark's immunity from easy alteration. The number "3," for instance, could easily become a "B" or an "8." The letter "C" could easily be altered to become an "O."

Brands could be any size, but three to seven inches in both height and width were customary. At times, as an animal grew, so did the brand, often

Branding irons
Mackay, Idaho

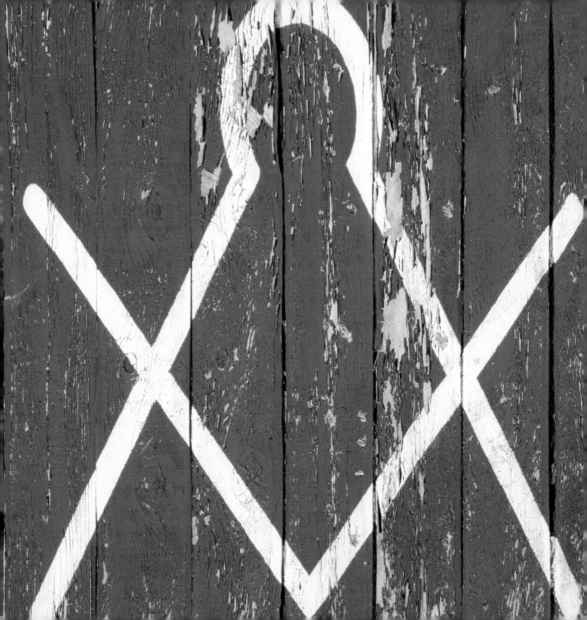

becoming more than one foot tall. In later years, due to complaints from leather tanners about ruined hides, brands tended to be restricted in size and were generally placed on an animal's hindquarters.

Unmarked cows were called "mavericks." Although there are many theories on how they got that name, one widely accepted account explains the origin of the term. In 1845, a Texas attorney and rancher named Samuel Maverick received several hundred longhorn cattle in lieu of his fee. Maverick, not being much of a cattleman, never branded the animals. After some time, the herd grew quite large and a few larcenous ranchers in the surrounding area decided to brand some of Maverick's cattle as their own. Soon ranchers began saying, with a laugh, "Let's go brand some Mavericks."

Unmarked cows were called "mavericks."

As animals were sold, they accumulated new markings. They often wound up bearing the brands of several ranches as well as "county" brands (a series of letters denoting a specific county, not unlike today's ZIP codes). A well-schooled observer could divine the history and travels of a cow simply by reading the marks on the animal's flank.

Matador Ranch brand, one of the oldest in Montana
Dillon, Montana

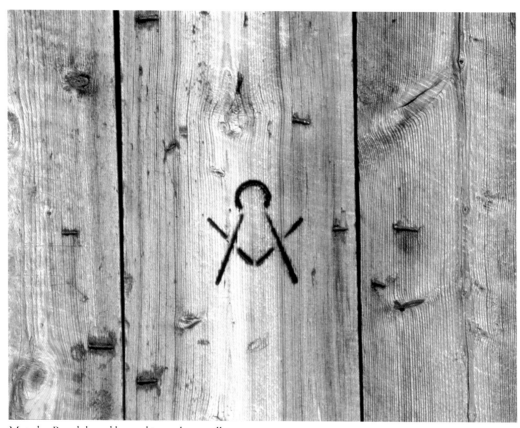

Matador Ranch brand burned into a barn wall
Dillon, Montana

A sign with a star and the "square and compasses"
Masonic symbol, similar to the brand of the Matador Ranch.

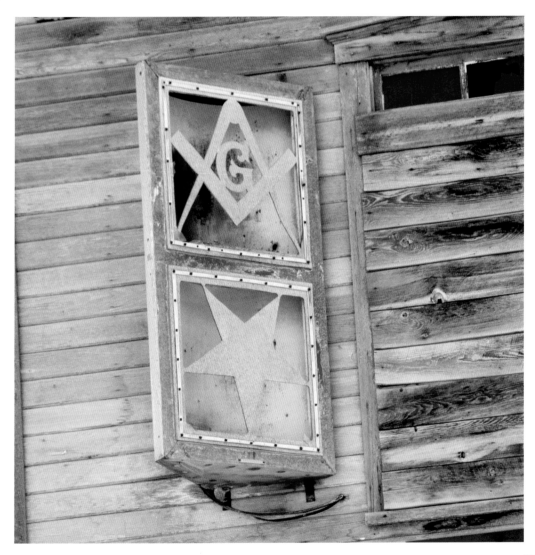

"Your foot in the stirrup
and your hand on the
horn, you're the best
durned cowboy that
ever was born."

—— The Old Chisholm Trail

Gate sign with historic brands
Waggoner Ranch
Vernon, Texas

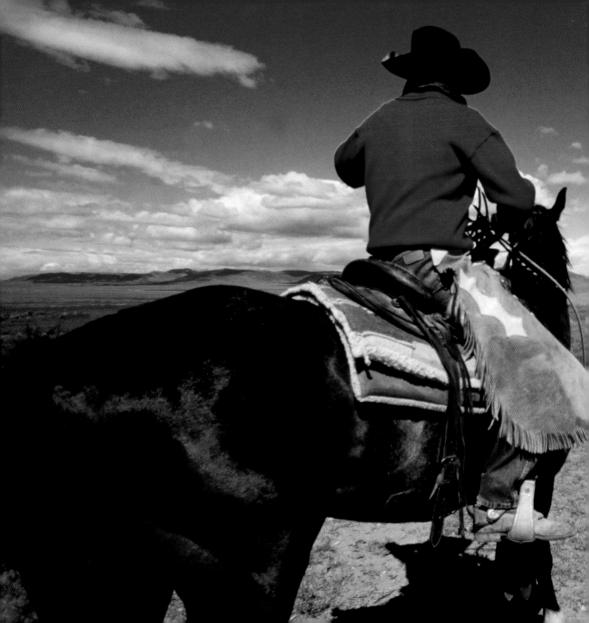

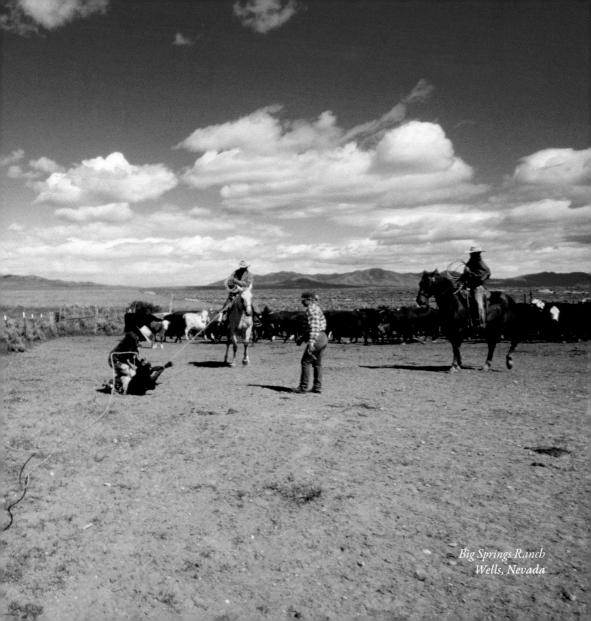

Big Springs Ranch
Wells, Nevada

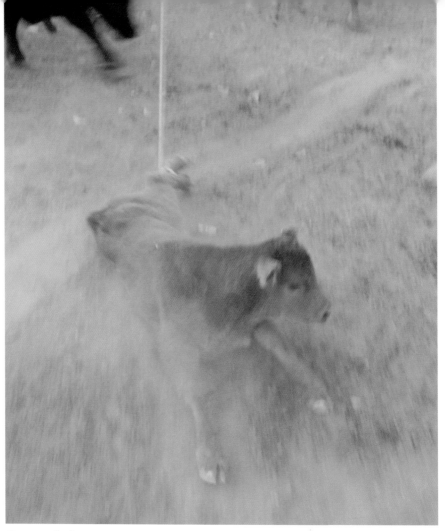

Going to the fire
Dragging Y Ranch
Dillon, Montana

Branding action
Jack Ranch
Paso Robles, California

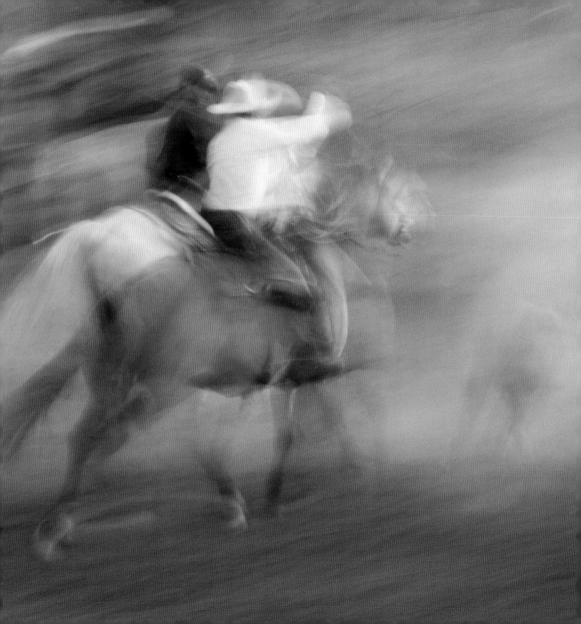

The Branding Camp

In the spring, the big ranches roll out the chuck wagon for the annual branding. Some crews are out on the range for months, branding seven days a week and some just head out for a week or the weekend.

The days when branding crews gathered vast herds of cattle in West Texas and Montana, Wyoming and California, Arizona and New Mexico are almost gone. I have been fortunate enough to photograph some of the last of the wagons pulling out and I have slept with these crews under the stars, out on the range with the sounds of cattle, horses, and cowboys snoring away.

Some of the great outfits that still pull a wagon or set up a big branding camp are the Pitchfork Ranch in Texas, the Padlock Ranch in Wyoming, the YP Ranch in Nevada, and the Haythorn Ranch in Nebraska. There is a lot of fun to be had in a branding camp. The cowboys all have amusing stories to tell and the riding and roping is entertaining to watch and photograph. The food is always delicious and plentiful.

Branding camps are a great tradition and I am so thankful to the ranches that have helped to keep this important part of the West alive.

—DRS

Branding camp
06 Ranch
Fowlerton, Texas

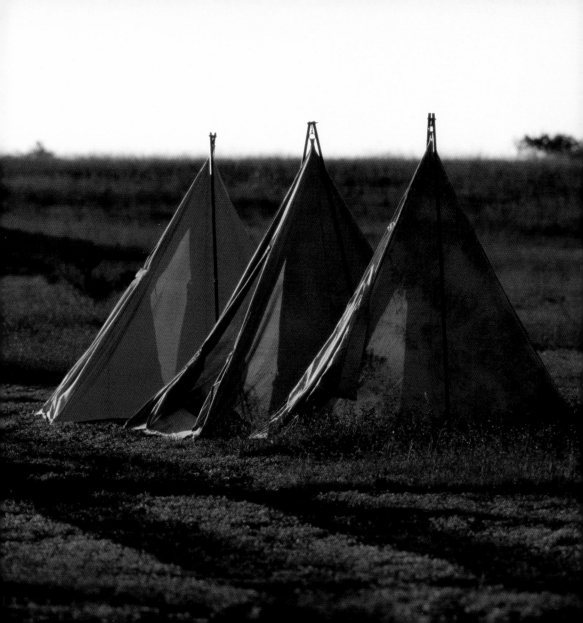

The Winecup brand is one
of the most sought-after
brands in the West.

Winecup Ranch branding iron
Wells, Nevada

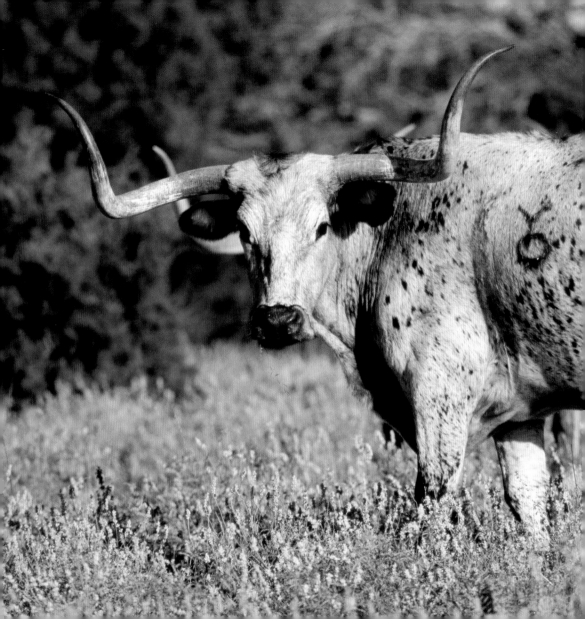

Texas longhorns
Y.O. Ranch
Mountain Home, Texas

Y.O. Ranch

The Y.O. brand was first used on the Texas Gulf Coast in the 1850s by Youngs O. Coleman of the Fulton family ranching empire near Rockport. Eventually the brand changed hands and made its way to the Texas Hill Country near Kerrville. In 1880, Texas Ranger Captain Charles Schreiner purchased the Y.O. Ranch, its brand, and cattle from Taylor and Clements with the profits he made by driving more than 300,000 head of Texas longhorns "up the trail" to Dodge City. Five generations of the Schreiner Family have operated the Y.O.—a tradition that continues today.

(reprinted from the Y.O. Ranch web site—www.yoranch.net)

Y.O. Ranch gate
Mountain Home, Texas

King Ranch

The true meaning of King Ranch's "Running W" brand remains a mystery. Some have said that it represents one of the ranch's many diamondback rattlesnakes or the Santa Gertrudis Creek, while others are sure it signifies the sweeping horns of a Texas longhorn bull. The "Running W" could also be interpreted as a section of a continuing wave pattern—signifying the uniting of the past with the present and suggesting continuity into the future. Regardless of its meaning, the "Running W" brand is handsome and practical, designed to heal quickly, thwart rustlers, and grow with the animal that bears it—just as it has evolved with King Ranch through the generations. Today the "Running W" appears on both prize-winning cattle and top quality leather goods as an indisputable icon of the American ranching industry.

(reprinted from the King Ranch web site—www.king-ranch.com)

King Ranch gate
Kingsville, Texas

Four Sixes Ranch
6666

The Four Sixes Ranch has a storied history that began with a poker game and a winning hand of four sixes—reputedly, but not so. In true Texas fashion, it does make a good story, though. The real history of the Four Sixes began with Samuel Burk Burnett, who became one of the most influential and prosperous cattlemen in Texas. Before the age of 20, he purchased from Frank Crowley in Denton County a herd of cattle wearing the 6666 brand. With the title to the cattle came ownership of the brand. Burnett recorded the brand in 1875 in Wichita County, Texas, on the Kiowa-Comanche Reservation in 1881 and in other counties in years following.

The origin of the 6666 brand and why it was used by Crowley is unknown. But it had nothing to do with a card game. The Four Sixes Ranch continues today as a forerunner in the cattle industry. The quality of Four Sixes cattle is well known. The ranch is also recognized for its exceptional horses. The brand used on the Sixes' horses is the same one burned on the first horses Burk Burnett bought. Records reveal those cow horses were acquired from Captain M.B. Loyd of Fort Worth, who became Burk's father-in-law. The horses were branded with the letter "L" on the left shoulder, as they are today.

(reprinted from the 6666 Ranch web site—www.6666ranch.com)

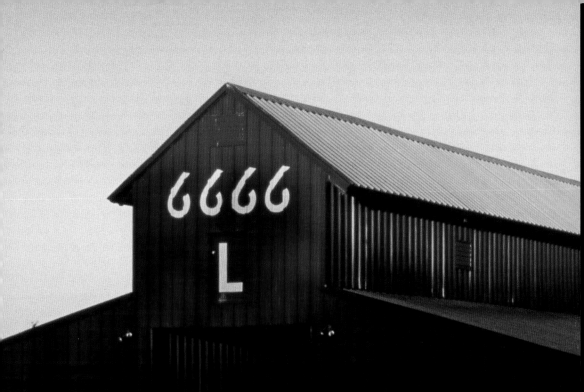

6666 Ranch barn
Guthrie, Texas

How to Read a Brand

(reprinted from *Cowboy Gear*)

In early ranching days, a cowboy was supposed to be able to read brands and tell whether they had been tampered with. Horses are typically branded only once. Cattle usually get a new brand each time they are sold. The accepted way to read brands is from left to right, top to bottom, and from the outside inward. A dash is read as a "bar." Diamonds or circles retain their names. Using those guidelines, the letter "b" on its side and over a line signifies the Lazy Bar B. An "o" inside a diamond shape is the Diamond O. Capital letters are called "big," hence a brand reading "A-8" signifies the Big A Bar 8 Ranch. A "B" within a circle identifies the Circle Big B spread. Circles also appear in segments of varying lengths, describing quarter, half, or three-quarter circles.

Brands surrounded by quadrilaterals are called boxed, block, or square. A letter or figure resting on its side is "lazy," while it is "running" or "tumbling" if leaning forward. If resting atop a quarter-circle, the mark is "rocking." Within a wing design, it is "flying." A "U" atop another inverted "U" is called a "wallop." A set of crossed parallel bars is called a "hog pen." Some examples of early brands and their translations are on the following page.

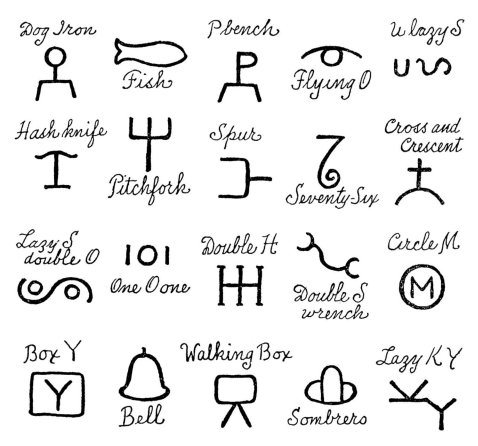

Dog Iron

Fish

P bench

Flying O

U lazy S

Hash knife

Pitchfork

Spur

Seventy-Six

Cross and Crescent

Lazy S double O

One O one

Double H

Double S wrench

Circle M

Box Y

Bell

Walking Box

Sombrers

Lazy K Y

Reprinted from *Trail Dust & Saddle Leather*
© Stoecklein Publishing and Joe Mora

Following page: On the way to branding camp
Haythorn Ranch, Arthur, Nebraska

Binion Ranch

J

Lester Ben "Benny" Binion was a legend in the West. He was a cow man, a horse man, and a rodeo stock man, as well as the owner of Binion's Horseshoe, a Las Vegas casino. Benny designed his brand using his wife, Teddy Jane's, initials. The brand was first registered in Carlsbad, New Mexico in about 1939 and was first marked on a little sorrel horse named Joe. Joe lived for 32 years.

Eventually the Binion brand was registered in New Mexico, Texas, Montana, and Nevada where Binion had ranch operations. Today, his daughter Brenda Michael owns the brand and has continued the family ranching tradition.

Benny was known as a friend of the rodeo cowboy and his Horseshoe Casino still pays the entry fees for all the national finalist rodeo cowboys and cowgirls. The "TJ" brand is well known and respected among the rodeo crowd.

Binion Ranch brand
Jordan, Montana

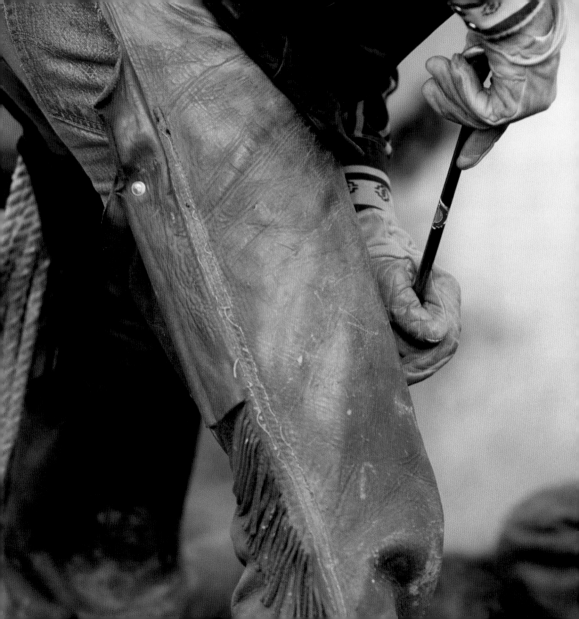

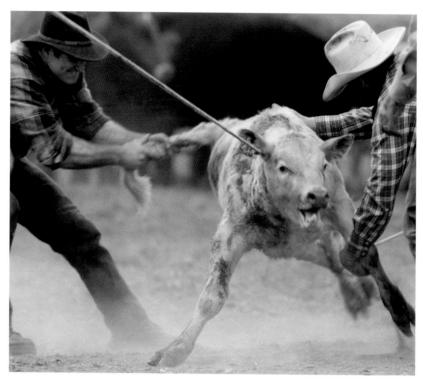

In mid-air
Three Creeks Ranch
Elk Creek, California

Hot iron
Hubing Ranch
Broadus, Montana

K-K water tower
Picabo Livestock
Picabo, Idaho

King Ranch water tank
Kingsville, Texas

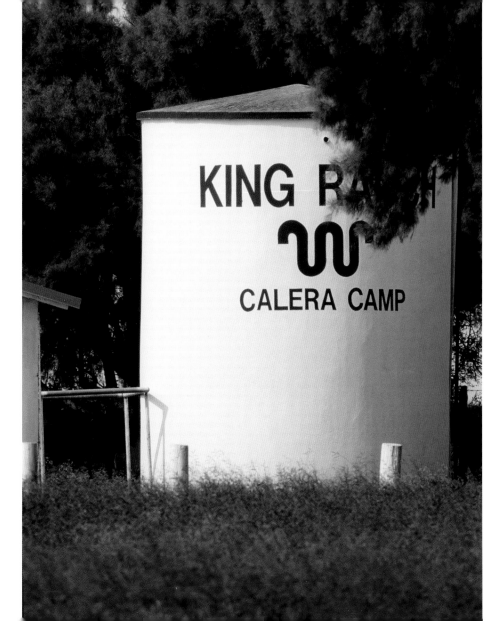

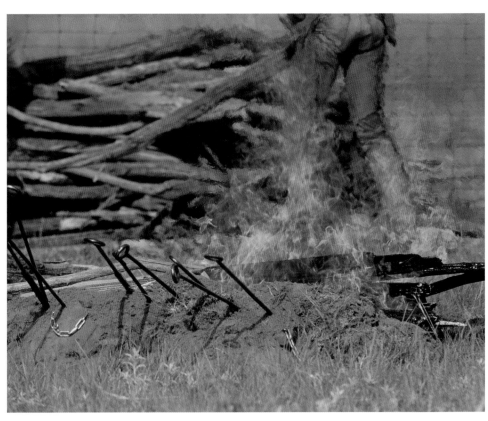

Branding fire
Haythorn Ranch
Arthur, Nebraska

Burning the hair off the iron
Hubing Ranch
Broadus, Montana

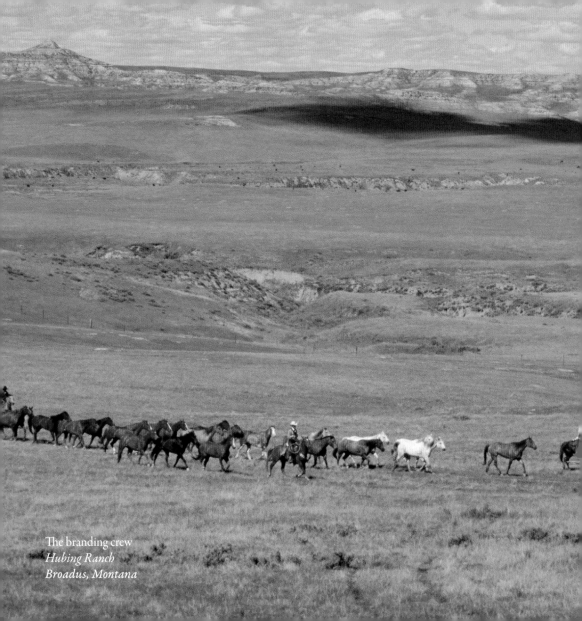

The branding crew
Hubing Ranch
Broadus, Montana

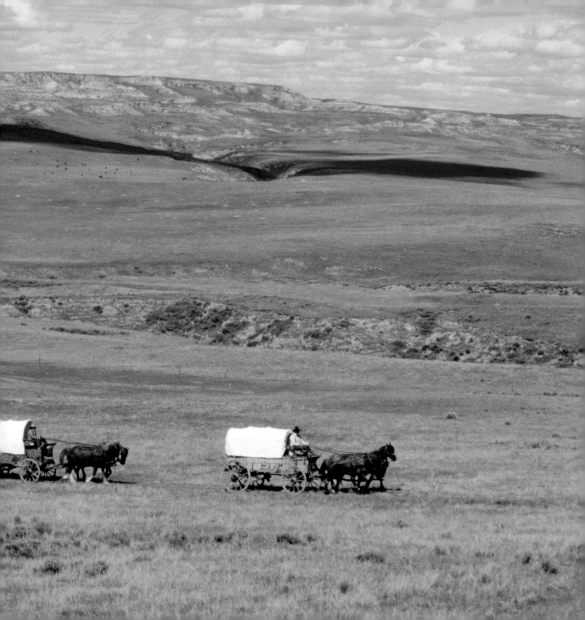

The Branding Crew

by Louise Wilson, The Wilson Ranch, Ridge, Montana

We started using the wagons to brand in this neighborhood in the mid-70s and have used them off and on ever since. The chuck wagon belongs to Jim Wilson and Francis Hayes. It is believed that the wagon originally came from Nebraska in 1900 with a man by the name of Charlie Maples, who homesteaded what is now known as the Espy Ranch at Boyes, Montana. When Jim Espy purchased the ranch in 1956, the wagon had not been used in a long time. It was full of scrap iron, the tongue had been cut off short, and the wheels had rotted. Jim Wilson and Francis Hayes hauled the wagon to their place after Jim Espy gave it to them. Francis spent most of his spare time one winter finding missing pieces of hardware and rebuilding the box. Jim and Francis reworked and shrank the wheels and made new bows for the wagon and then wrapped them with rawhide. The bedroll wagon belongs to Dick Dinstel, and he spent a lot of time rebuilding it.

Over the years, many different people have worked on the crew, but Jim has always been the wagon boss. Generally speaking, the crew consists of about seven to ten men, one man from each ranch that wants "the wagon" to brand for them. Those men agree to stay with the wagons until the job is done. It is a form of trading help. Of course, each ranch also invites other friends and neighbors to help on their branding day.

Using the wagon gives us a means to do things the "old way," to pass on some skills and knowledge to a younger generation while getting a necessary job done—and it's fun! It

provides a change of pace to the normal spring routine. Even when we branded with pickups and horse trailers, we probably didn't get any more work done, since we all came home and took naps! Now, when we move camp to a new location, we might move some cows to fresh pasture, brand a little bunch of calves, or put somebody's bulls out for them in the afternoon. In the course of a week to ten days, we will move about 25 miles, be in five or six different camps, and brand 2,500 or so calves.

Every man brings his own horses, generally two or three—and there is usually a green horse or two to keep things interesting. We carry a rope corral with us, as most of the camps do not have permanent corrals, and the loose horses are trailed behind the wagons when we move. At the beginning of the season, the chuck wagon leaves with all the cooking utensils and enough groceries to run three or four days. After that, fresh groceries are brought in as needed. The rancher whose calves are being branded furnishes the meat for the main

meal, and at the end of the branding run the rest of the groceries are pro-rated among the participating ranches. It is not a for-profit deal, that's for sure! Our main concessions to modern times are Coleman lanterns, coolers, and a chainsaw. Camps will have two or three cowboy teepees, and one four-man and one six-man tent. Playing cards and poker chips also seem to be a necessity!

The remuda
Hubing Ranch, Broadus, Montana

Freeze Brands

by Jack Goddard

The freeze brand is the most common form of animal identity and is used mostly by horse owners and cattle seed-stock producers. The irons are made of copper or bronze and can be of any design. Copper and bronze hold temperature very evenly, similar to the electric iron. Rather than using heat to alter the hair cells, liquid nitrogen cools the temperature of the metal so low that it kills the pigment-producing cells of the hair by instantly freezing them. Unlike the hot iron that burns a mark and then forms a scar in the form of the brand design, the freeze brand turns the hair white in the form of the designed brand image. The procedure is to shave the hair in the area to be branded and apply the brand. There is a slight initial sting for the animal, but the extreme cold instantly numbs the area and is quite painless and humane. This method leaves a beautiful white image on a horse's hide as opposed to a scar. Some horse breeders prefer the old fashioned look of a hot iron brand over the white-haired mark, but it is a personal preference. Seed-stock cattle producers also use the freeze brand to identify cattle for reasons other than ownership, such as pedigree of sire and dam, calving dates, lot numbers, and so forth, without scarring the hide.

Jaw brand
Singleton Ranches
Santa Fe, New Mexico

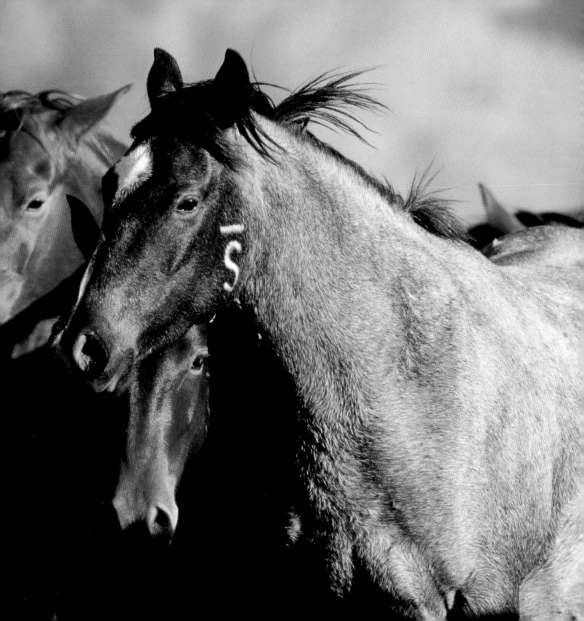

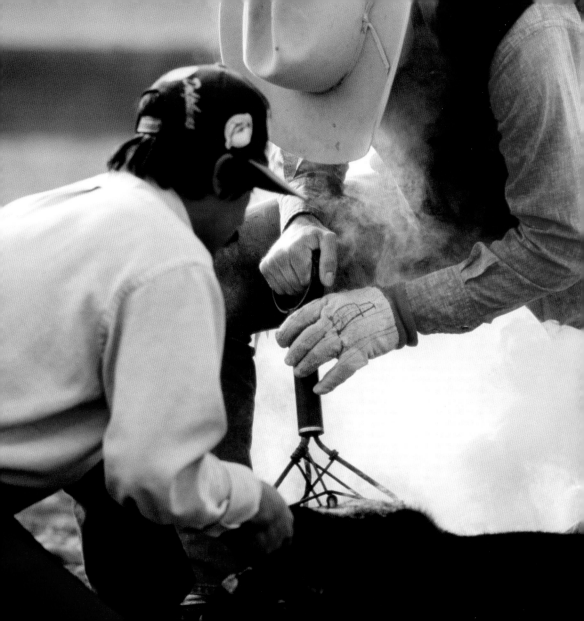

Electric Iron

by Jack Goddard

Modern technology has led to the most common form of branding used today with the advent of the electric iron. The even and constant heat of the electric iron has almost eliminated the blotched effect of uneven and overheated irons. Any brand, including closed loops and shapes such as diamonds and hearts, can be used effectively. Today, there are countless registered brands made up of any and all types of artistic designs. The electric brand has also eliminated the need for open flames to keep irons hot. Enormous feedlot operations have made the electric iron popular because it is a safe and fast tool to identify thousands and thousands of head of cattle that come and go on a daily basis.

Electric iron
Cross Ranch
Grant, Montana

Saddle blanket
Tejon Ranch, Lebec, California

Tejon Ranch

The "cross and crescent" Tejon Ranch brand was recorded in Kern County in 1868. The configuration of the Christian cross and the Muslim crescent is traced back to Old Spain around 997 A.D. A Spanish ranching family brought the brand to Mexico and their descendants carried the brand to the Tejon Ranch.

Ranching is much like it was in the 1880s, with cattle and cowboys roaming the vast ranges. Records show that Gen. Edward Beale, the founder of Tejon Ranch, returned to the ranch in 1880 after serving as minister to Austria-Hungary, and shifted his focus from sheep to cattle. Years of drought had severely impacted his sheep operations, which at their peak had grown to an estimated 125,000 sheep. By 1891, an appraisal made by W.H. Holabird for Tejon Ranch showed the cattle count at 25,000 and sheep at 7,500. There were 350 mules and horses and 200 miles of fence listed in the report.

Today, cattle operations have been turned over to two livestock tenants. Matt Echeverria, former livestock manager and interim president for Tejon Ranch, runs cattle on a 55,000-acre lease on the northlands portion of the ranch, while Centennial Livestock leases 195,000 acres in ranchlands, southlands, and valley lands areas to the south.

(reprinted from the Tejon Ranch web site—www.tejonranch.com)

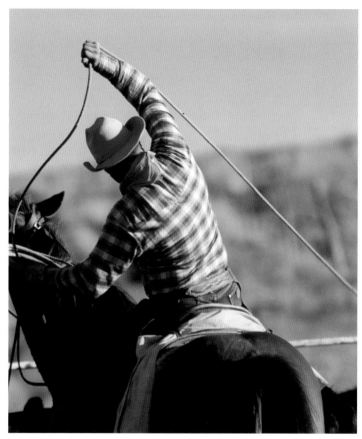

Going to the dally
Hubing Ranch
Broadus, Montana

Chet Vogt holding steady
Three Creeks Ranch
Elk Creek, California

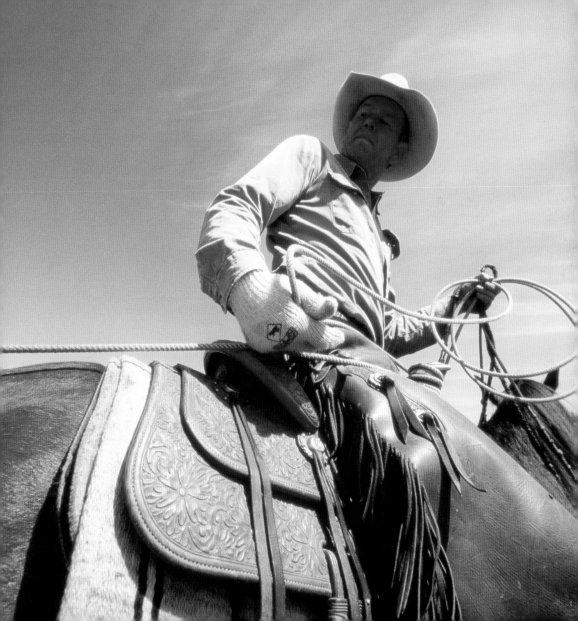

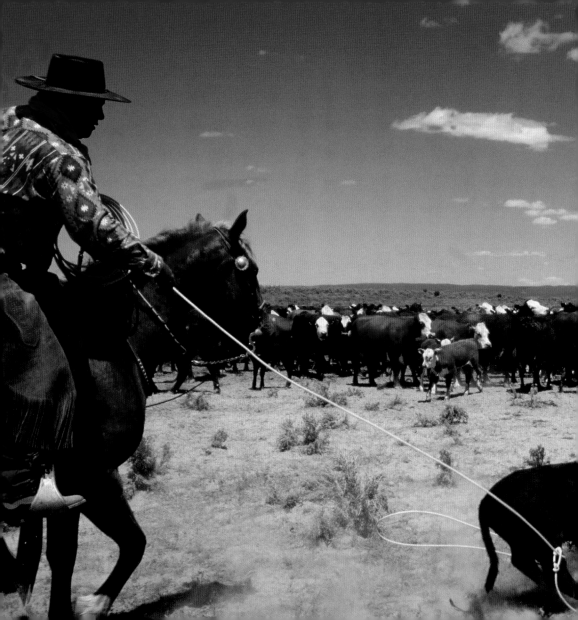

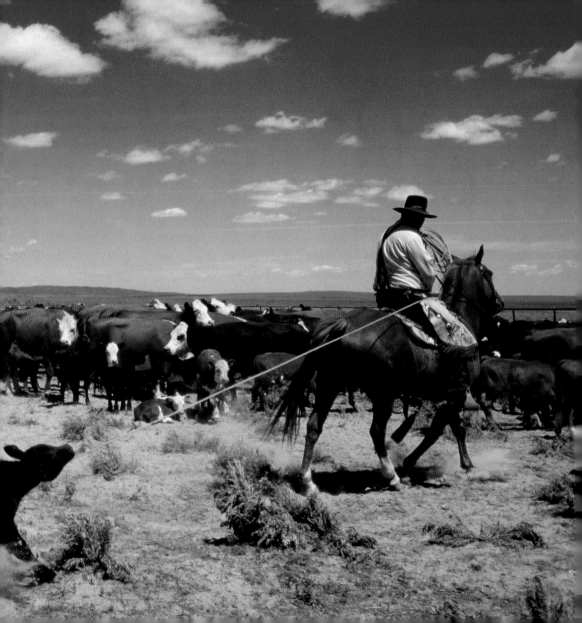

Previous page: Heading and healing
YP Ranch
Tuscarora, Nevada

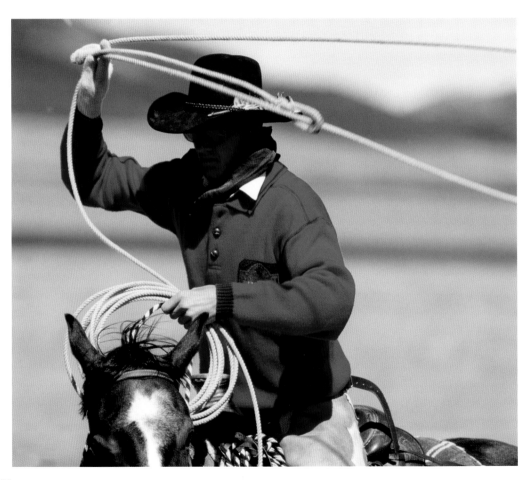

Heading and Healing

Very few outfits head and heal their calves any more. Most only heal them. Some people claim it is because there are just not enough good ropers out there to do it properly, and some say it puts too much stress on the calves. In my opinion, it is the most fun way to brand.

It is amazing to watch a branding crew with cowboys who know how to head a calf and bring it to the fire while the healer catches the calf by the feet right at the fire. I see this method used most often on ranches in California, Nevada, and western Idaho. It is the old Spanish style and is done with a strong sense of tradition in mind.

—DRS

Will Black
Big Springs Ranch
Wells, Nevada

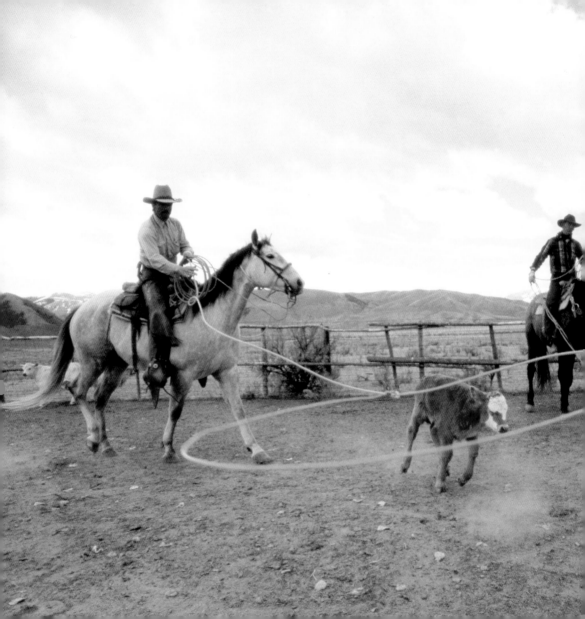

The big loop—Luis Velasco
and Steve Schroder
Dragging Y Ranch
Dillon, Montana

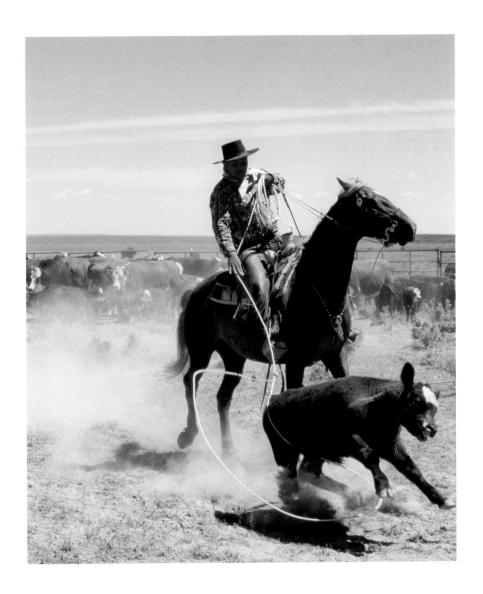

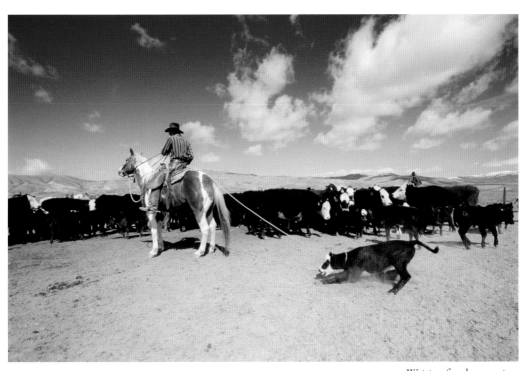

Waiting for the opening
Matador Ranch
Dillon, Montana

Norbert Gibson throws a great loop
YP Ranch
Tuscarora, Nevada

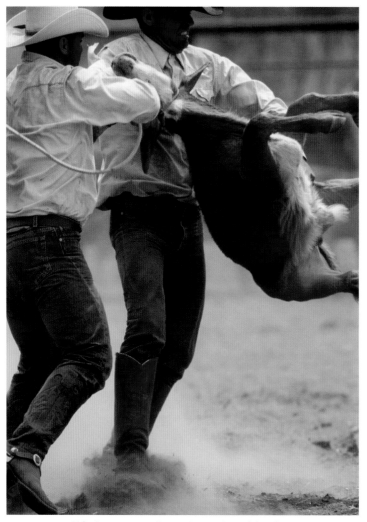

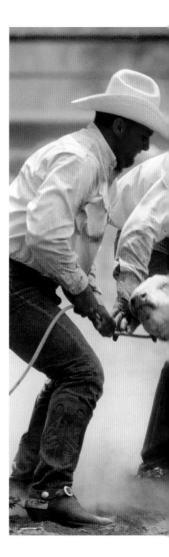

114 degrees and no shade for 100 miles

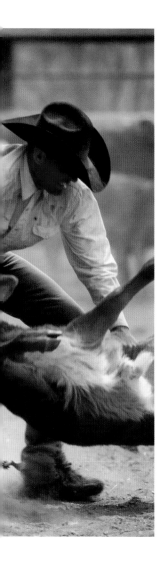

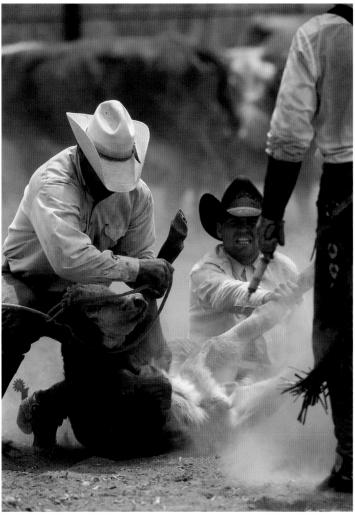

Kyle Everson and Bubba Smith
Pitchfork Ranch, Guthrie, Texas

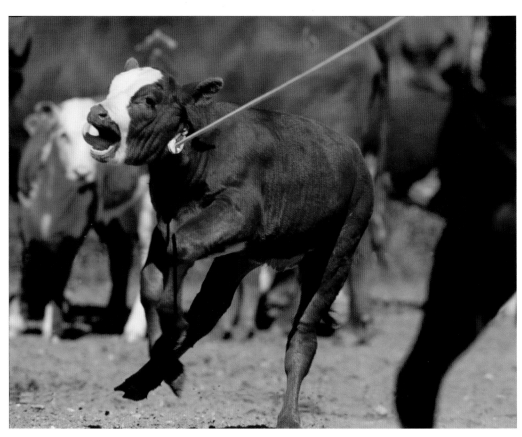

Bawling calf
Big Springs Ranch
Wells, Nevada

"Next morning at daybreak in a circle we ride,

we round up the doggies, take down the rawhide,

we rope them and brand them like in days of old,

upon the left shoulder we stamp the 8-0."

——The Pecos Puncher

Hip brand
Miller Land & Livestock
Big Piney, Wyoming

Shoulder brand
Pichfork Ranch
Guthrie, Texas

The Two Calves

When I was working on *The Montana Cowboy* book, I spent a day on the Dragging Y Ranch photographing their spring branding. Those cowboys love a good time and sometimes that good time comes at my expense. They know how I like to "play cowboy," and they had a horse ready for me to use so I could entertain them all with my horsemanship and roping skills. Right away, I got bucked off amidst much laughter and they told me that the horse always bucked people off when they first spur him.

After some roping and lunchtime laughter, the ranch owner, Roger Peters, told me that the whole ranch had been eager for me to arrive because Steve Schroder had been reading a book about an old cowboy who could really rope at a branding. They told me to get my camera so that he could demonstrate one of the old cowboy's tricks.

Steve had loops on both ends of his rope and proceeded to rope two calves and drag them both to the fire at the same time. I had never seen done this before and have not seen it done again since. I was truly impressed.

—DRS

Steve Schroder and Roger Peters
Dragging Y Ranch
Dillon, Montana

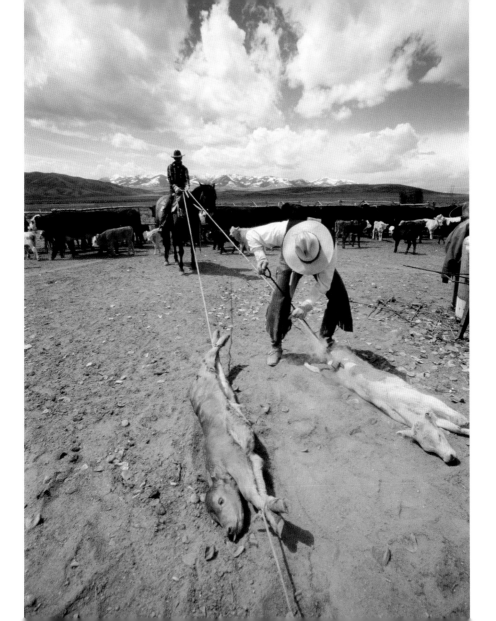

Rocky Mountain Oysters

by Jack Goddard

Mention the term "Rocky Mountain Oysters" or "Prairie Oysters" and it will undoubtedly bring snickers and sly smiles to a branding crew. Oysters used in this context are not borne of saltwater depths but are in fact, calf testicles. Usually, during the branding, some unfortunate soul has the undignified task of collecting the "oysters" for the ceremonial rite of cooking and eating the delicacy. The task usually falls to some poor kid who carries around a can, sack, empty vaccine box, or any other container to "harvest the oysters." They can be cooked on the branding pot or with any iron heated by the branding fire. Once they are cooked sufficiently to satisfy the preference of the trained cowboy palate, the outside shell or membrane is split with a sharp knife and the sweet delicacy is squeezed or spooned out with the thumb and eaten with hearty gusto, either genuine or contrived to bond the brotherhood of the crew. A cowboy's hands at a branding are coated with sweat, dirt, calf manure, and dried blood. The thumb used to extract the oyster is far from sanitary but this only adds to the branding experience. Sampling this delicacy of the prairie or the Rocky Mountains is not for the faint of heart.

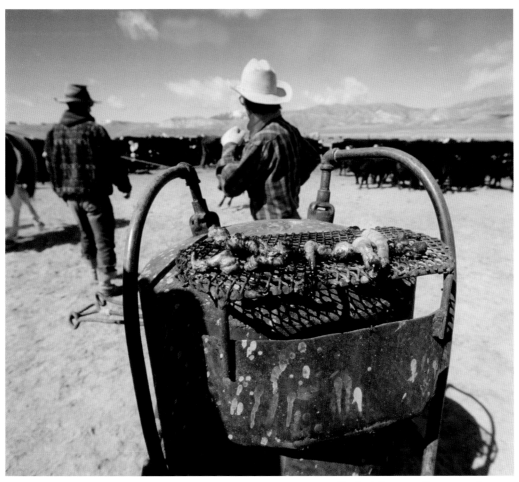

Rocky Mountain Oysters, ready to eat
Matador Ranch
Dillon, Montana

Ready to make Rocky Mountain Oysters
Big Willow Ranch
Payette, Idaho

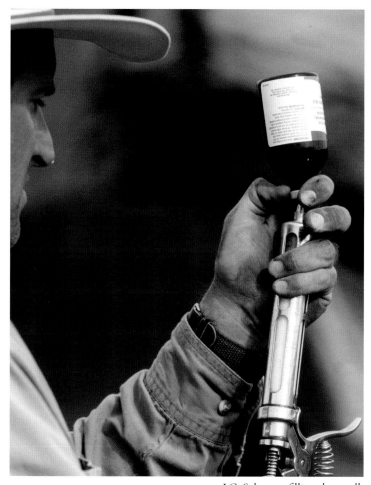

J.G. Schwartz filling the needle
Big Willow Ranch
Payette, Idaho

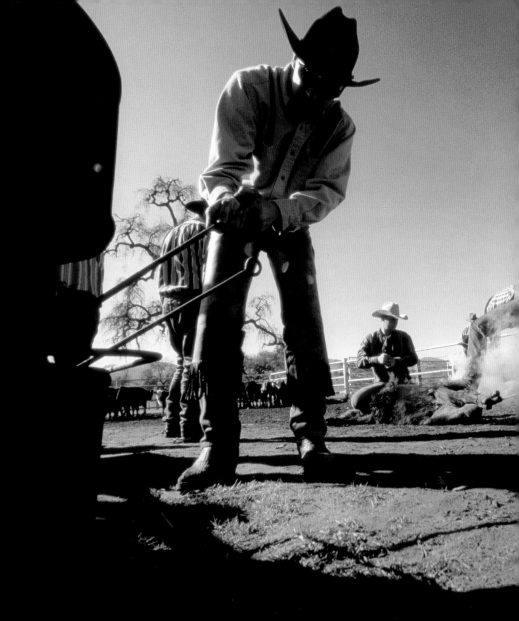

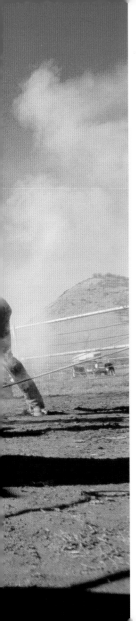

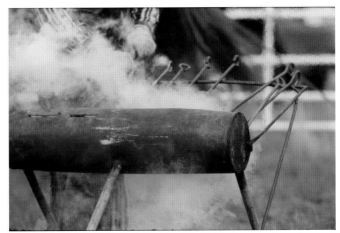

The branding pot
Hubing Ranch
Broadus, Montana

Branding crew
Yokohl Valley Ranch
Yokohl Valley, California

Waiting for a calf
Haythorn Ranch
Arthur, Nebraska

Tight rope
Three Creeks Ranch
Elk Creek, California

Eatons' Guest Ranch
Wolf, Wyoming

Eatons' Guest Ranch was the first dude ranch in America. Their brands are fun and unique——the horse, the arrow, and the Bar Eleven.

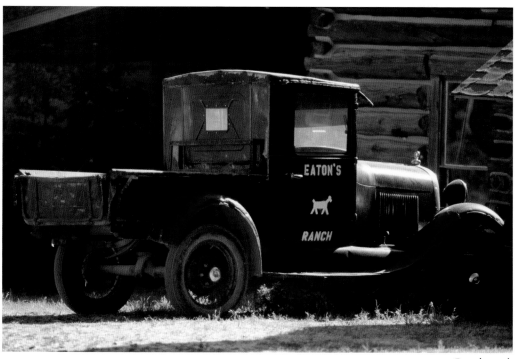

Ranch truck
Eatons' Guest Ranch
Wolf, Wyoming

"We fellows don't know how to plow

Nor reap the golden grain,

But to round up steers and brand the cows

To us was always plain."

——Bronc Peeler's Song

Bar Horseshoe Ranch
Mackay, Idaho

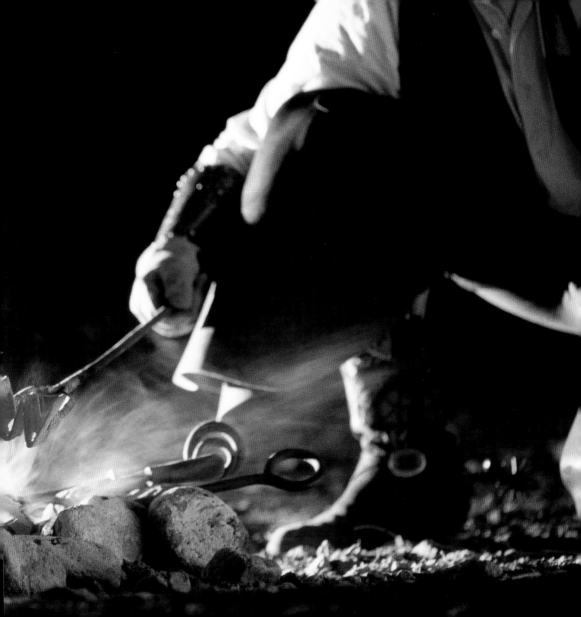

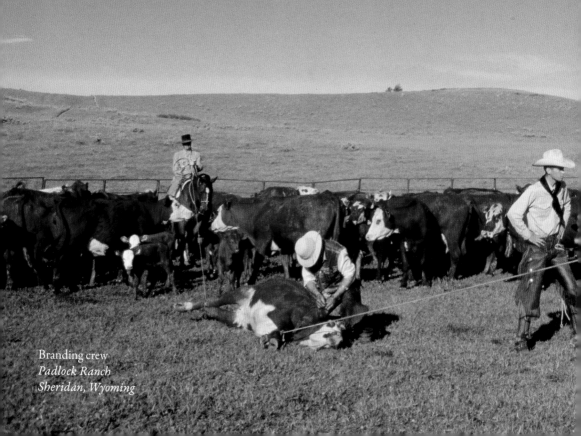

Wyoming cowboys hang their slickers to one side so as not to get caught up in the rope when they drag a calf to the fire.

Branding crew
Padlock Ranch
Sheridan, Wyoming

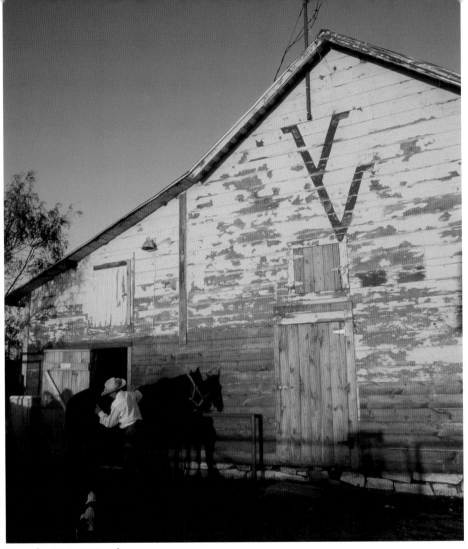

Saunders Twin V Ranch
Weatherford, Texas

Thomas Saunders' spurs
Weatherford, Texas

This brand has been passed down through three generations of the Saunders family.

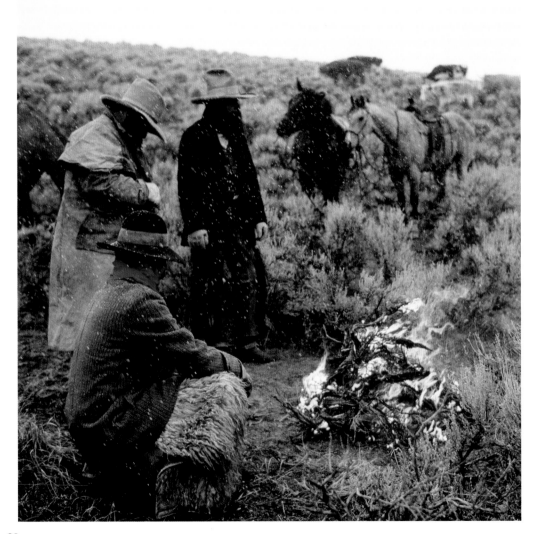

The running iron
Saunders Twin V Ranch
Weatherford, Texas

Running irons were an important tool for the early
branding teams, and later, for cattle thieves.
They are still outlawed in most states.

"The Rustlers"
Jay Hoggan, Raymond Jayo, Brett Reeder
Mackay, Idaho

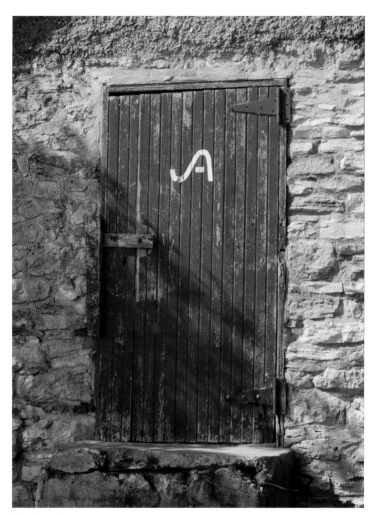

JA Ranch
Clarendon, Texas

JA Ranch

In 1876, Irishman John Adair rode with Charles Goodnight from Pueblo, Colorado to the Palo Duro Canyon. Just two years earlier, the Native Americans had been subdued on what was to become the ranch near Battle Creek. They soon formed a five-year term partnership with Goodnight. He provided the know-how and the Adairs supplied the money to purchase the land to control the grazing of almost one million acres of land on both sides of the Palo Duro Canyon. John Adair's initials became the ranch brand.

JA represents not just cattle, horses, land, or cowboys. A long line of families has made the JA what it is. Each year hundreds of former and present employees and their families join together for the JA reunion. People who are brought up on the JA have the same attachment to the brand that those who ride for the brand today have.

(reprinted from the History of the JA web site—www.ranches.org/JAranch)

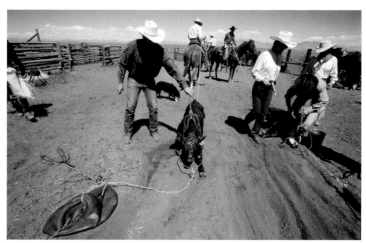

Using a "dead man" and a "Nord Fork" to secure a calf
Von Wood Ranch
Arco desert, Idaho

A "dead man" is a rubber tire tube that is
anchored to the ground and used to hold a calf
steady while leaving a little spring in the rope.

A "Nord Fork" is a branding device that was invented by Nord Hill of Taber, Idaho. It holds a calf's head still while a cowboy brands it.

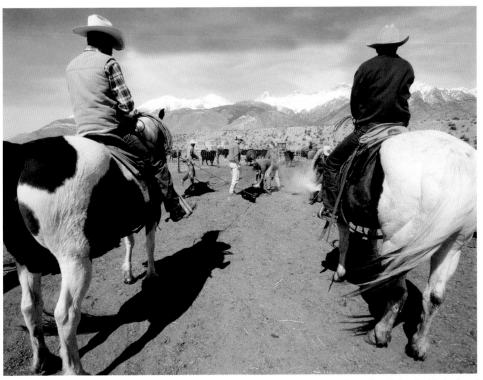

Using a "Nord Fork" to hold the head
Zollinger Ranch
Mackay, Idaho

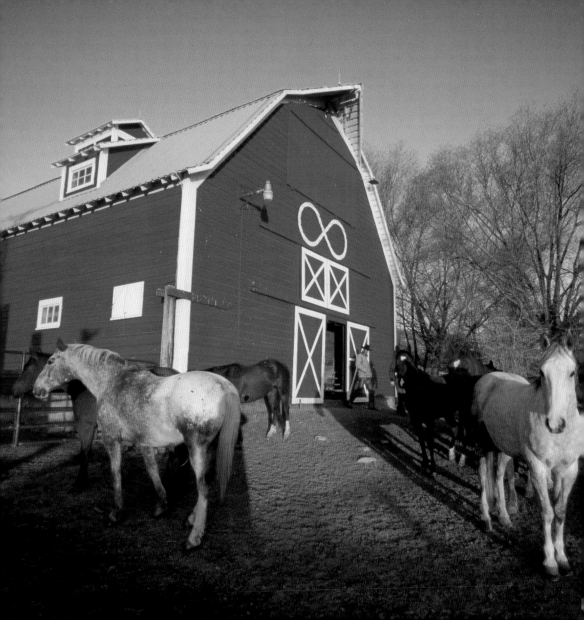

King Ranch barn
Kingsville, Texas

Lazy Eight brand
Selkirk Ranch
Dillon, Montana

Babcock Ranch
Valley View, Texas

Five Dot Ranch
Susanville, California

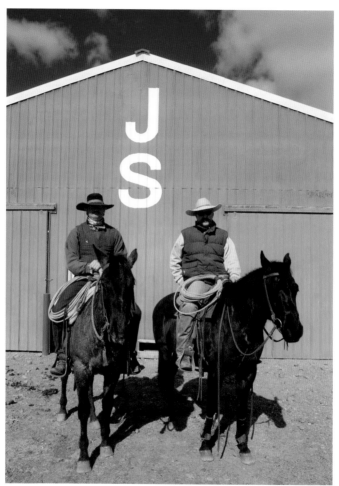

Robert Timmons and Shannon Allison
Simplot barn
Grand View, Idaho

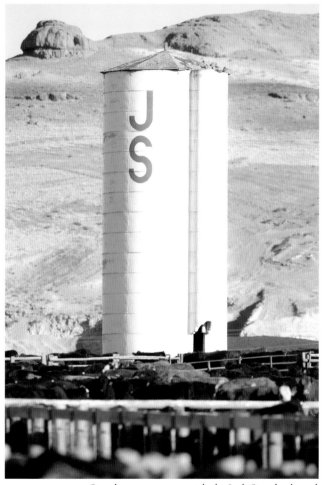

Simplot water tower with the Jack Simplot brand
Grand View, Idaho

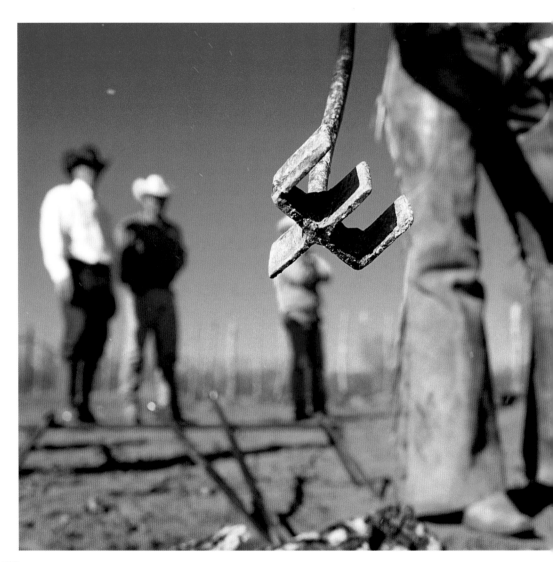

Riding for the Brand

by Herb Mink

I grew up quickly and didn't get a hell of a lot of help or sympathy from anyone. But I worked for the brand all the time. If you're going to work for the man who writes the checks, there are two things you can do. You can do what he says, or you can quit. If he says to tie a rock around every cow's neck and hurl them off the tough end of the Snake River, you work at it just as hard as if you were trying to put all the meat on those cows that you could.

Riding for the brand is important. You stick up for the outfit you work for. Even if you know the boss is wrong, you stick up for him. You might tell him one-on-one that you think he's wrong, but you don't run to the neighbor, or to the pool hall, and tell everybody what a no-good son-of-a-bitch your boss is.

To me, sticking up for the outfit and giving a day's work for a day's pay is just about the most important thing a cowboy can do.

Pitchfork Ranch
Guthrie, Texas

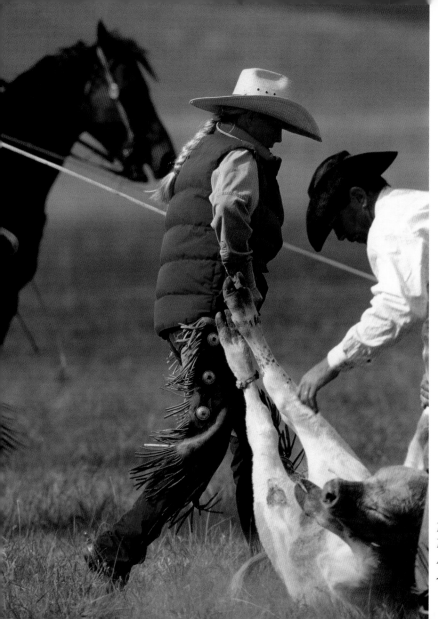

Branding at the
Haythorn Ranch
Arthur, Nebraska

Mitzi and
Mark Goodman
Haythorn Ranch
Arthur, Nebraska

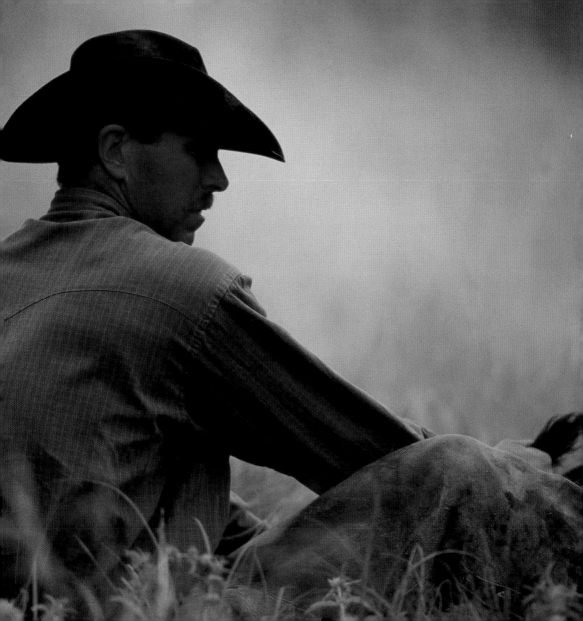

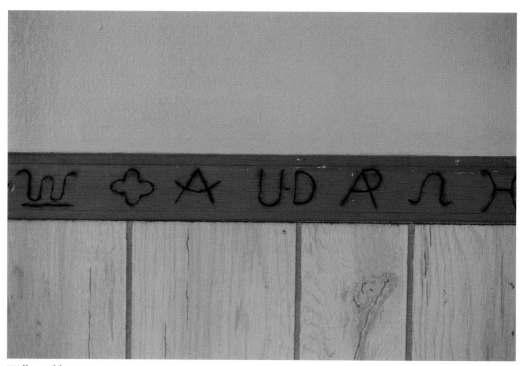

Wall moulding
Jordan Valley, Oregon

Chair from old Mexico
Rancho el Fortin
Coahuila, Mexico

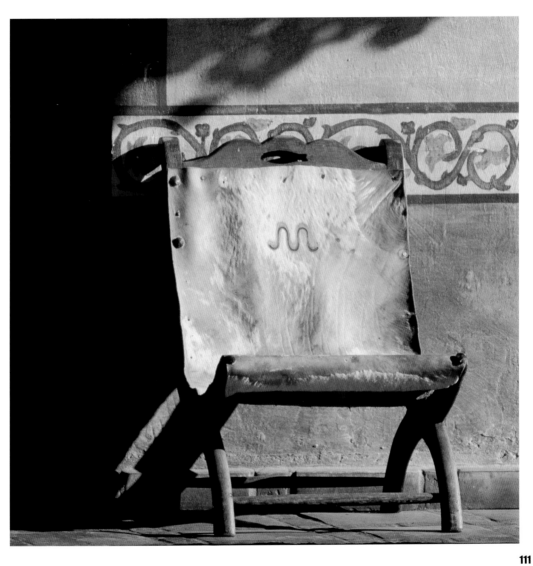

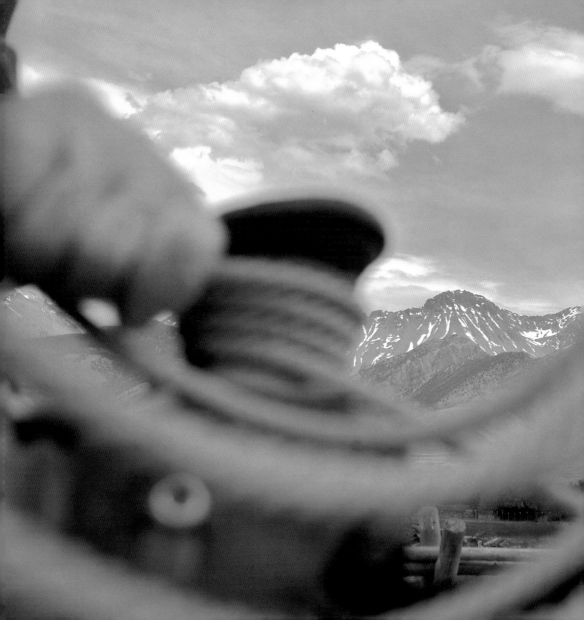

Through the loop
Big Lost Range
Zollinger Ranch
Mackay, Idaho

The Brand Inspector

The brand inspector is a law man in the true sense of the old West. Back in the early years of ranching, the inspector was hired by the big outfits to check for brands on the cattle before they went up the trail and when they got to the railhead. In some states, like Texas, the brand inspector still works for the Cattlemen's Association. In Idaho, however, the inspector works for the state. In states like Texas, a rancher must register a brand in every county and in other states, like Idaho, a brand is registered once for the entire state.

One of the tricky things is to register a brand in every state. There is a chance that the same brand exists in several different states. Placement of a brand makes a difference as well—one ranch might have a brand that is on the animal's left hip, while another ranch could have the same exact brand, but on the left rib. All brands are kept in a state brand book and are registered there. The inspector is in charge of keeping it all straight.

Branding laws also change from state to state. In Idaho, for example, a rancher must notify the brand inspector when he is moving horses or cattle between counties. A brand inspector's job is a tough one. Thieves steal cattle and horses even more today than in the old West and the law men have a tougher job catching the rustlers, who use modern horse and stock trailers to hide their plunder.

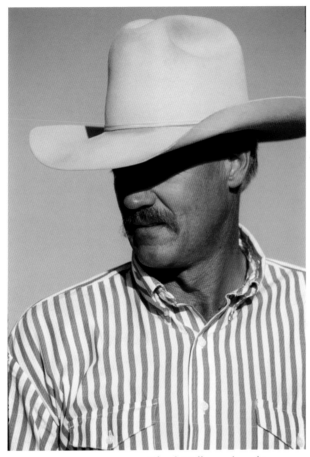

Chuck Hall, state brand inspector
Bruneau, Idaho

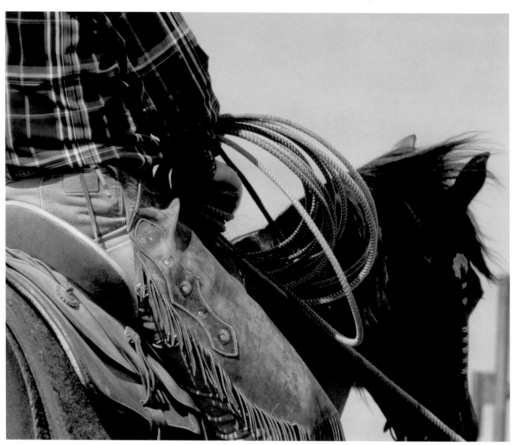

Holding at the fire
Wellman Ranch, California

Buckaroo's saddle horn
Idaho

Well-worn Mexican saddle horn
Rancho el Fortin, Coahuila, Mexico

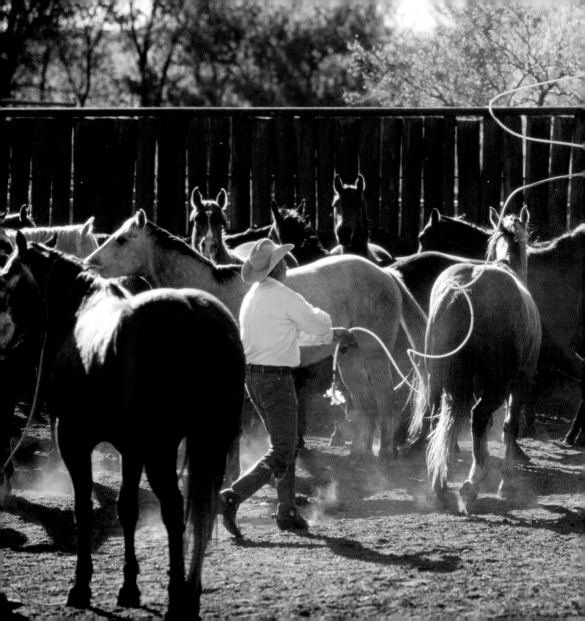

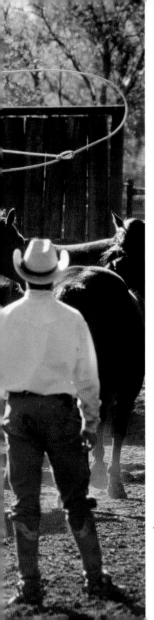

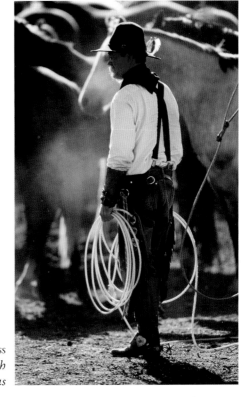

David Ross
Pitchfork Ranch
Guthrie, Texas

James Gholson throws
a big loop
Pitchfork Ranch
Guthrie, Texas

Horses are chosen, fed,
and groomed for the next
day's branding.

Door handle
Y.O. Ranch
Mountain Home, Texas

Circle Bar Guest Ranch brand made from rope
Utica, Montana

I once saw a cowboy wearing his brand in eight different places: stirrups, spurs, spur straps, boots, chaps, belt, belt buckle, and scarf.

Not to mention, the brand was also on his headstall, saddle, and of course, his horse! (his name was Tom Saunders IV)

——DRS

Branding Time

Spring is branding time in ranch country. Brandings can be family affairs, community affairs, or just work for the ranch cowboys. Usually, the neighbors call and they all show up to help. Everyone likes to rope and show off their skills. Typically, there is a large lunch or dinner where people share stories from the past year or tales about the best catches and wrecks from the day. It is also a time to show off a new horse and catch up with friends in the area.

On the big outfits, a branding is all business, as there are thousands of new calves to brand and it seems to take all spring to get it done. The huge ranch brandings are fun, but the work often starts at four in the morning and can go on all day with no end in sight.

I try to go to as many brandings as I can. My friend Tom Hall, who is now in his mid-eighties, puts his horse in the trailer every day during the spring and goes off to any brandings he can find nearby. When I grow up, I want to be just like Tom.

—DRS

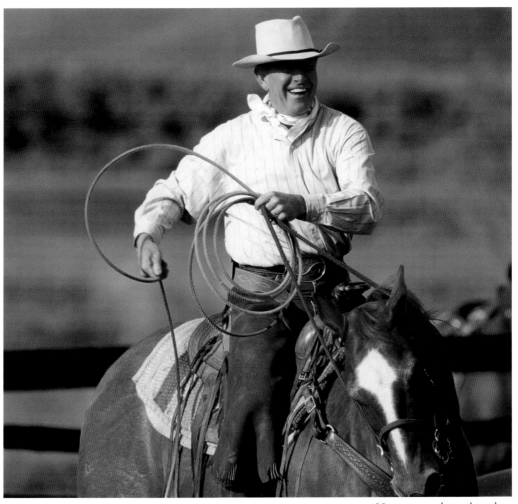

Having a good time branding
Idaho State Governor, Butch Otter
Big Willow Ranch, Payette, Idaho

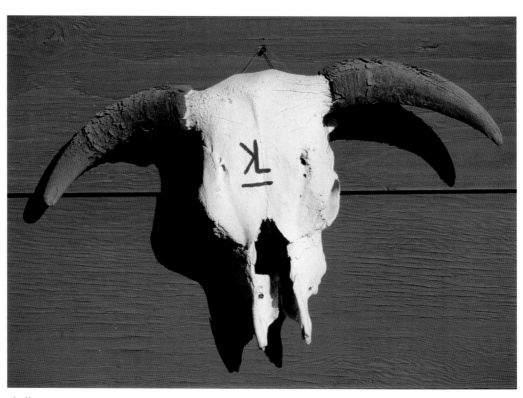

Skull
Kay El Bar Guest Ranch
Wickenburg, Arizona

Fancy gate
Cojo-Jalama Ranch
Lompoc, California

The Chuck Wagon

(reprinted from *Cowboy Gear*)

The chuck wagon was a welcome sight to any cowboy after a day on the range. Though not always serving the best grub a hand ever had, a chuck wagon, sometimes called a trail wagon or commissary, was always sure to fill his belly at day's end.

The chuck wagon served many purposes. Besides being the place where "Cookie" mixed up the stew, it was also the camp's hospital and social center, as well as a place where hands could store their bedrolls and dry clothes. On any given night around the chuck wagon, a cowboy could count on a warm fire, some conversation, and a place to sit down and roll a smoke.

Many attribute the invention of the chuck wagon to Charles Goodnight in 1866. However, in his book, *Trail Dust and Saddle Leather,* historian Jo Mora offers two accounts of chuck wagon use before Goodnight's. One story claims a man named McCutcheon assembled and used a "camp cart" in 1857. Another account describes a man, identified only as Reed, trailing a wagon on a drive to Louisiana at the outbreak of the Civil War in 1861. Regardless of its inventor, cowboys were clearly better off once the chuck wagon became standard equipment on cattle drives. Before Goodnight customized and popularized the chuck wagon, cowpunchers were responsible for their own grub. This meant they ate and wore whatever they could stuff into their saddle bags.

Chuck wagon at sunset
Arco, Idaho

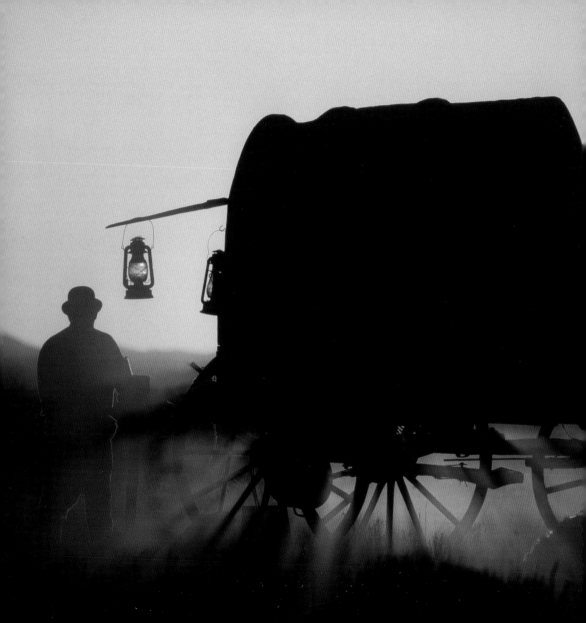

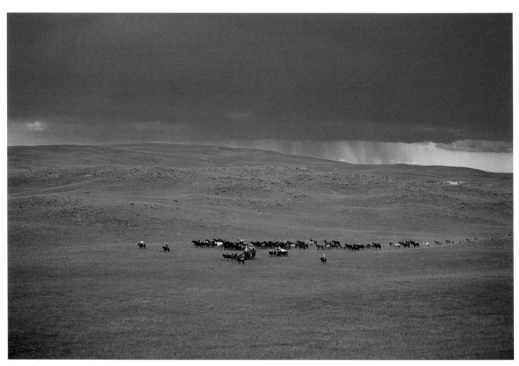

Branding crew and chuck wagon on the trail
Haythorn Ranch
Arthur, Nebraska

The chuck wagon itself was most often a converted Army surplus or conventional springless farm wagon. It was pulled by four oxen in the earliest years, and later by mules or horses. It was usually fitted with a large "chuck box" in the rear, which held the cook's tools in several drawers and shelves. The lid of the box, when lowered, could be used as a work table.

On long drives, the underside of the chuck wagon might be fitted with a rawhide apron called the "possum belly" or the "coonie." It was used to store dried buffalo chips—cow chips in later years—or wood for use as emergency fuel. Inside the wagon was lashed a water barrel with a faucet that protruded through the side of the wagon box. At the front of the wagon rested the "jewelry box," holding a range of miscellaneous tools, bullets, and other occasionally used items.

When cattle drives first began making use of a chuck wagon, the camp cook was hired primarily for his ability to drive a team of oxen or horses. The cook was, often as not, a terrible chef. In *Cowboy,* author Philip Ashton Rollins furnished a definition of the early trail cook as "...a man who had a fire; who drew the same wages that he would have earned if he had known how to cook." Along with cooking and maintaining the working condition of the chuck wagon, the cook was also the camp doctor, and was in charge of repairing leather harnesses and other gear.

On a cattle drive, a poor rider was often called "Cookie." Still, overt criticism of the cook was rare, since a cowpuncher complaining unduly about the cook could, by custom, be pressed into service as the cook's helper or replacement for a day's time. Rollins related the anecdote of the quick-thinking puncher who blurted out, "This bread is all burned, but gosh, that's the way I like it."

The camp cook was always up before the crack of dawn, preparing the first of three hearty meals he would cook throughout the day. Cowboys were accustomed to eating at what they called "the sixes"—a meal at 6 a.m., another at noon, and one more at 6 p.m.

A good cook was a priceless asset to any outfit. He was a magician with beans, bacon (or "sowbelly"), and coffee. A good camp cook would do his best to keep variety in his meals, although most included beans, bread, and steak. On the Northern range, bread was usually made from wheat flour. In the South, Texans preferred cornmeal.

Whatever the grub, a cowboy could count on a thick cup of coffee to wash it down. Many cowboys commonly referred to coffee as "Arbuckles," after the popular Arbuckles brand of pre-roasted coffee. Sometimes a less financially fortunate crew resorted to a substitute coffee brewed from parched maize, sweet potatoes, or meal bran. A colloquial cow country recipe for coffee was: Add two pounds coffee to two gallons of boiling water. Boil two hours, then throw a horseshoe into the pot. If the shoe sinks, the coffee isn't done yet.

As they did with most everything else associated with their work, cowboys attached colorful descriptions to their food. For instance, "whistle berries" was the nickname for beans, eggs were called "crackle berries," canned milk was "canned cow," onions were "skunk eggs," and kidney stew was known as "son of a gun" stew. If the cook was feeling kind-hearted, he might whip up some "spotted pup"—rice and raisins—or some "plain pup"—rice and spices—for dessert.

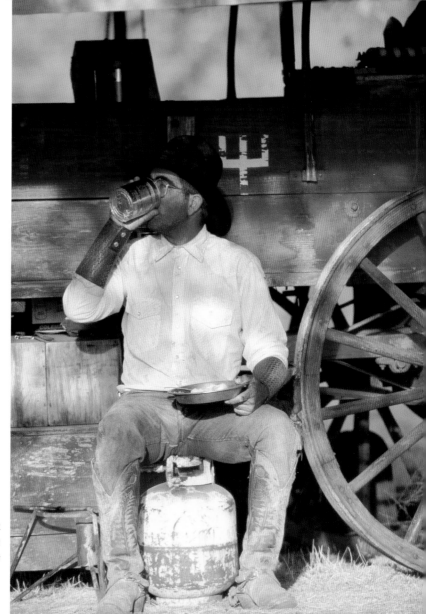

Lunch break
Pitchfork Ranch
Guthrie, Texas

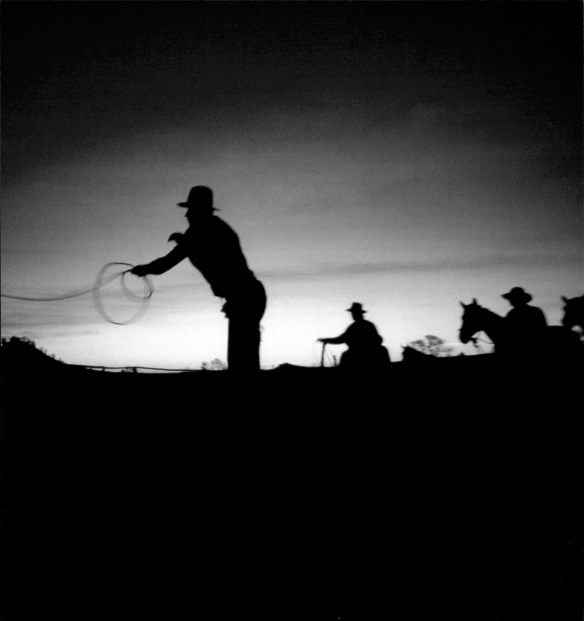

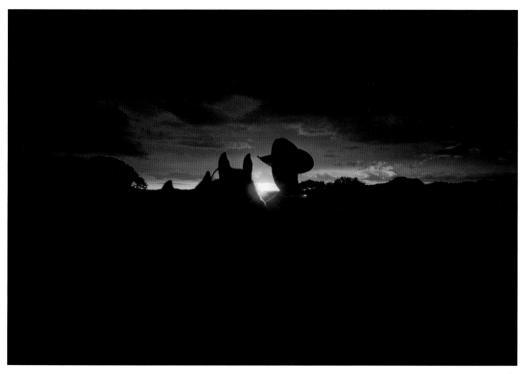

Up early
Chet Vogt
Three Creeks Ranch
Elk Creek, California

John Edwards picking out the branding mounts
Padlock Ranch
Sheridan, Wyoming

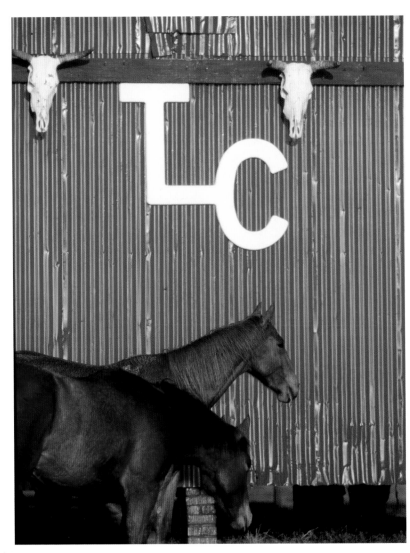

Gray Ranch
Vinton, Louisiana

Pick and shovel brand belonging to Kathy and Rowley Twisselman
Santa Margarita, California

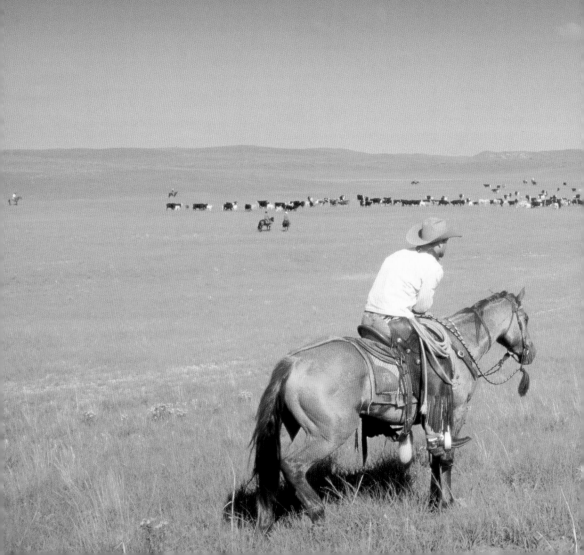

Spring branding
Haythorn Ranch
Arthur, Nebraska

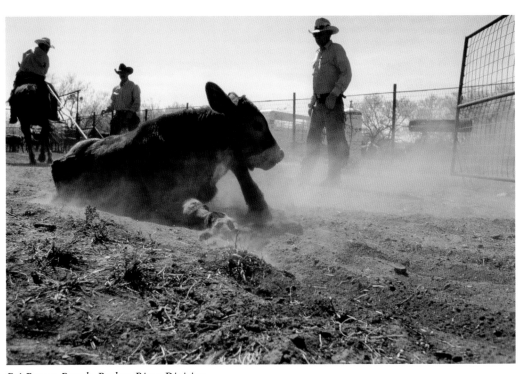

RA Brown Ranch, Broken River Division
Throckmorton, Texas

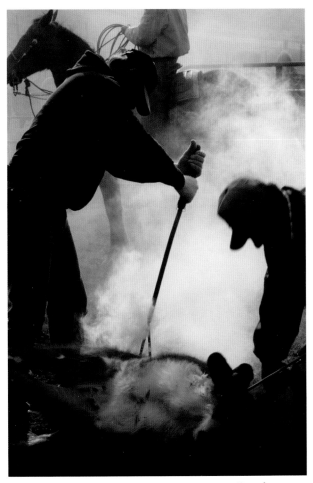

Branding crew
Righetti Ranch
Santa Maria, California

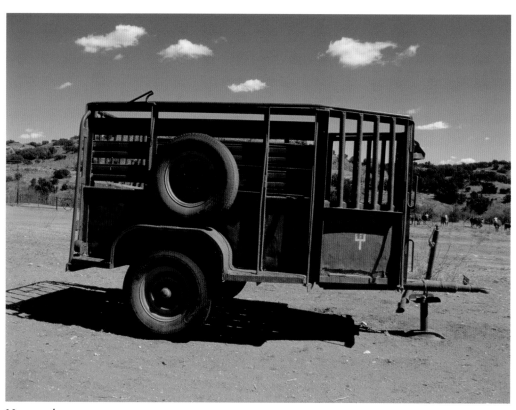

Horse trailer
Pitchfork Ranch
Guthrie, Texas

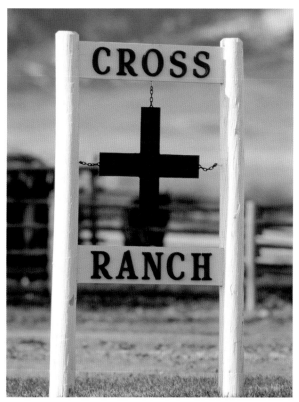

Cross Ranch
Grant, Montana

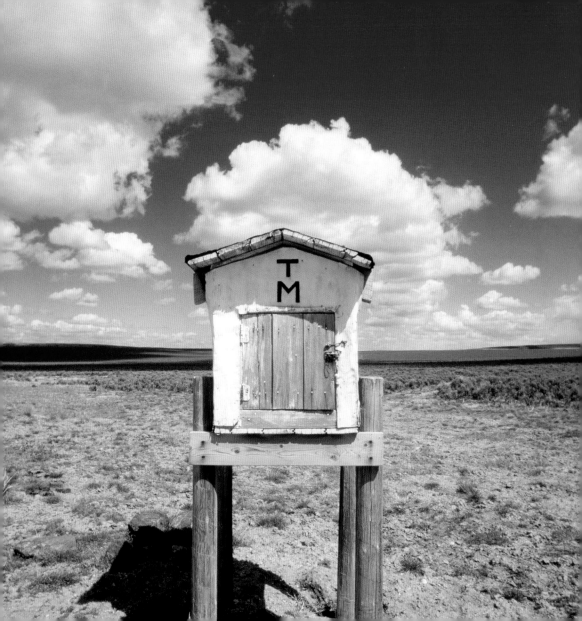

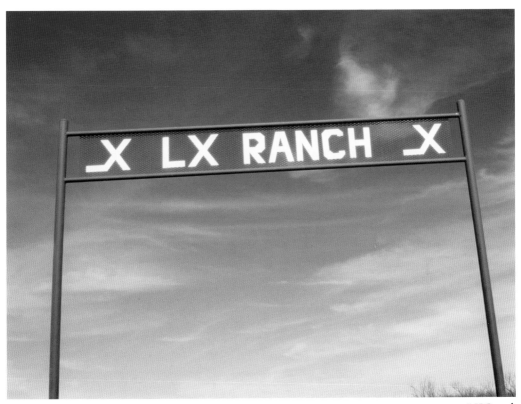

LX Ranch
Amarillo, Texas

Mailbox
Tuscarora, Nevada

Brand Marks of the Early Trail Drivers

(reprinted from *Cowboy Gear*)

(O Six) H.L. Kokernot Ranch, Alpine, Texas. The O6 brand was registered in Calhoun County as early as 1837. In the 1850s Capt. W.E. Jones registered the brand, and it was bought by J.W. Kokernot in 1872. Today the O6 holdings lie between Alpine and Fort Davis, Texas, and are managed by Chris Lacy Jr.

(Pitchfork) Pitchfork Land and Cattle Co., Guthrie, Texas. First registered in 1843, the Pitchfork brand was used upside down and did not have a middle prong. In 1879, a man named Jerry Savage ran cattle near the headwaters of the Wichita River using the Pitchfork brand upright and with a middle prong. Today the Pitchfork brand is used on cattle on 165,000 acres in Texas, on 32,000 acres in Wyoming, and on 4,000 acres in Kansas. Jim Humphreys is presently the vice president of Pitchfork Land and Cattle Co.

(Rocking Chair) Rocking Chair Co., Ltd., Collingsworth, Wheeler, Donley, Gray, Childress and Hall counties, Texas. The Rocking Chair brand came to Collingsworth County from the area around the Llano River about 1879. Today, Bill and George Arrington use the brand and another version of it is used by L.C. Whitehead, whose ranch is in Fort McKavett, Texas.

(Running W) King Ranch, Inc., Kingsville, Texas. The Running W brand, which appeared as the official brand of the King Ranch in the 1860s, may have originated by turning over an "M" brand that King acquired when he bought the land and livestock from William Mann in 1862. The brand has been burned onto the hides of thousands of cattle through the years, but since about 1950, the main breed of cattle to wear the Running W has been the Santa Gertrudis breed, which was developed on the ranch by then-ranch manager R.J. Kleberg Jr.

(Mill Iron) Mill Iron Ranches, Texas Panhandle. Col. Wm. E. Hughes, a Civil War veteran, organized the Continental Land and Cattle Co. In 1870, the company registered the Mill Iron brand. For many years the ranch was one of the best-known registered Hereford operations in the country.

(Turkey Track) Oliver Loving and Son, Jermyn, Texas. The Turkey Track brand, which is made with two irons, a half-circle and a bar, is still used today by Oliver Loving III.

(XIT) XIT Ranch, Texas Panhandle. Abner Blocker is generally credited with having devised the XIT brand, which is known throughout cattle country as one of the hardest brands for a thief to alter. In the early years, the brand was carried by as many as 150,000 longhorn cattle. The ranch began to slowly improve the native cattle by infusing blood of Hereford, Shorthorn, and Angus breeds. In 1901, the ranch began selling some of its land, and by 1912 the last of the XIT cattle were sold.

(Long S) C.C. Slaughter, Dallas, Texas. Rancher Slaughter is famous in Texas as

one of the first cattlemen to use English bulls to upgrade Texas longhorn cattle. He started the Long S brand in 1879.

(Long X) Reynolds Cattle Co., Fort Worth, Kent, and Dalhart, Texas. The Reynoldses were an early Texas ranching family. The Long X brand originated about 1882, and gave the 225,000-acre ranch in Jeff Davis County its name.

(Matador V) Matador Land and Cattle Company, Motley County, Texas. In 1879, John Dawson sold a herd of cattle wearing the "V" brand to Matador Ranch, and the ranch adopted the brand as its own. Today the ranch is run by Matador Cattle Co. out of Wichita, Kansas.

(Circle) Charles Goodnight and Oliver Loving, both trail drivers. In 1866, Goodnight and Loving established a cattle trail from Fort Belknap, Texas, to Fort Sumner, New Mexico. On the third trip, Loving was attacked and wounded by Indians. He sought cover near the Pecos River, and his repeating Henry rifle was buried in the mud. Loving later died, but the Henry, although wet, still worked. That incident brought credibility to repeating rifles and led to the development of the Winchester. The circle brand was Goodnight and Loving's road brand, and was only burned on cattle destined for the trail.

(Half Circle 10) George Saunders, San Antonio, Texas, cattleman, trail driver, and founder of the Trail Drivers Association. Saunders first started ranching as a teenager when his father and brothers left the family operation to fight the Civil War. In 1871, Saunders made the first of his nine trips in 15 years, trailing cattle from Texas to Kansas. In 1888, he started the George Saunders Commission Co., and later established

Union Stockyards, both in San Antonio. His father, Thomas Bailey Saunders, gave him his brand on his tenth birthday.

(SMS) SMS Ranches, Stamford, Texas. Svante Mangus Swenson, an immigrant Swede, came to Texas in 1836 and prospered in the mercantile business and banking. His wealth enabled him to acquire vast acreage in the Texas Rolling Plains. His sons, Eric and S.A. Swenson, developed this land for ranching and selected their father's initials as the ranch's brand. Legend says that the S's were branded backwards after a blacksmith mistakenly forged an iron that way.

(Four Sixes) Burnett Ranches, Inc., Fort Worth and Guthrie, Texas. Samuel Burk Burnett bought the brand in 1871, along with 100 cattle. A popular but untrue story is that Burnett's brand represented a winning hand he once had while playing poker for large stakes.

(Frying Pan) Glidden and Sanborn, Texas Panhandle. The Glidden and Sanborn 300,000-acre ranch was located on an old Indian camping grounds next to the XIT ranch. The operation began running the Frying Pan Brand, also called the Skillet and the Panhandle, in 1885, and it is currently recorded in a number of Texas counties by various cattlemen.

(JA) M.H.W. Ritchie, Clarendon, Texas. Col. Charles Goodnight selected the JA brand in 1876 to honor his partner, John Adair. The two men ran cattle in six panhandle counties. When Adair died in 1885, his widow continued the partnership until 1887, when the property was divided and she retained the JA brand and ranch.

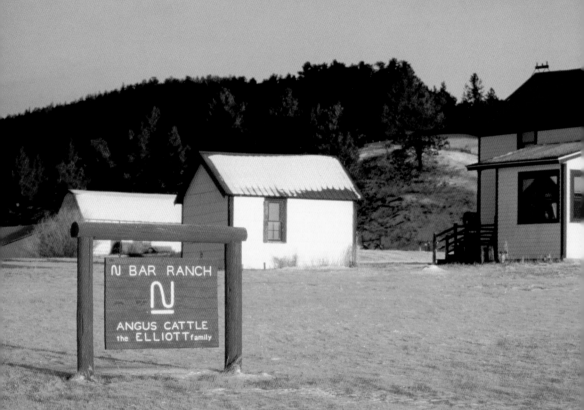

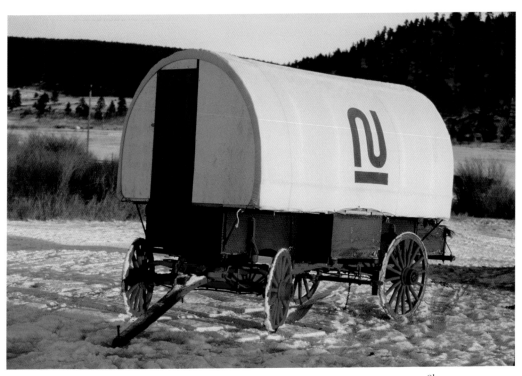

Sheep camp wagon
N Bar Land & Cattle Company
Grass Range, Montana

N Bar Land & Cattle Company
Grass Range, Montana

Justin Boots

Justin Boots, founded in 1879, is one of the oldest companies in the West. Branding for a business like Justin or Stetson or Wrangler or even Microsoft is everything. Most people never think that corporate branding is the same as branding cattle. But demonstrating pride in your ranch, your cattle, your horses, your products, or your company is all the same and it started with the cattle and the cowboys out West. A brand represents a reputation and a code of ethics and a moral code, whether it is for a corporation or a cattle ranch. You take pride in the brand, you ride for the brand, and you work hard for the brand.

—DRS

Haythorn Ranch
Arthur, Nebrasza

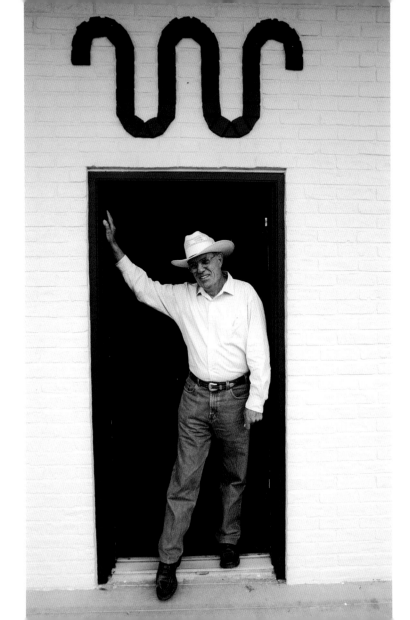

Dedication

I would like to dedicate this book to my good friend,
Dr. John Toelkes, D.V.M.

John is a man who rode for the King Ranch brand.
He is a true man of the West who has dedicated his life to his family,
to his love of horses and cattle, to the ranch that he loves,
and to the people of the King Ranch.

David R. Stoecklein

Dr. John Toelkes
King Ranch
Kingsville, Texas

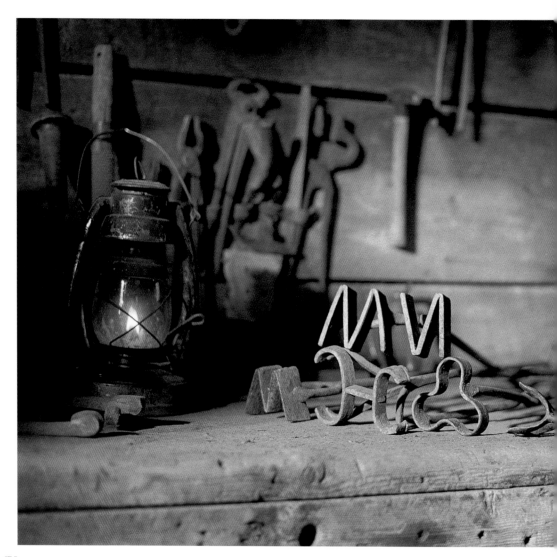

"Saddle up boys, and saddle up well
for I think these cattle
have scattered to hell."
——The Old Chisholm Trail

Antique branding irons in the old blacksmith shop
Bar Horseshoe Ranch
Mackay, Idaho

Other books from Stoecklein Publishing

Janell Kleberg's boots
King Ranch
Kingsville, Texas

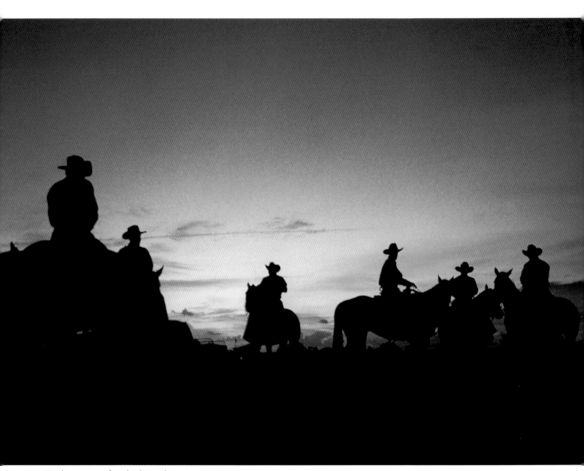

Early muster for the branding crew
King Ranch
Kingsville, Texas

Technical Notes

I use Kodak film and Canon cameras and lenses for all the photography in my books and in my commercial work as well. I use a variety of different cameras from Canon, including the EOS 1N and the 1V. As for lenses, I use the 300mm and 400mm f/2.8L IS USM and the 16-35mm and 28-70mm f/2.8L USM and 70-200mm f/2.8L IS USM zooms. I also use prime lenses like the 20mm f/2.8 USM, 35mm and 50mm f/1.4 USM. I use the Canon Image Stabilizer lens whenever I can, which happens to be most of the time. I shoot mostly digital now, using the Canon Mark II and Mark III cameras.

All of the slide film for this project was processed at the BWC lab in Dallas, Texas. They have been processing the film for all of my books as well as the 35mm film for my regular assignments for the last thirteen years. We have a great working relationship, one that is essential in this line of work to maintain consistency and accuracy.

I am extremely lucky to have all the good people at Canon USA and BWC as a support team while I fly around the country on assignments. Without all of them, my job would be much more difficult.

—DRS

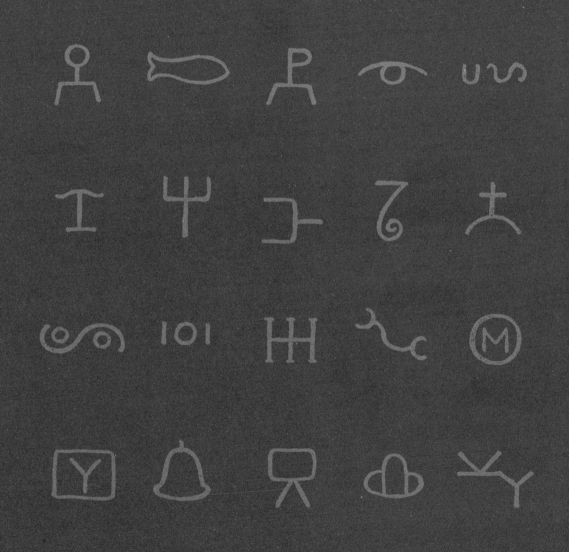